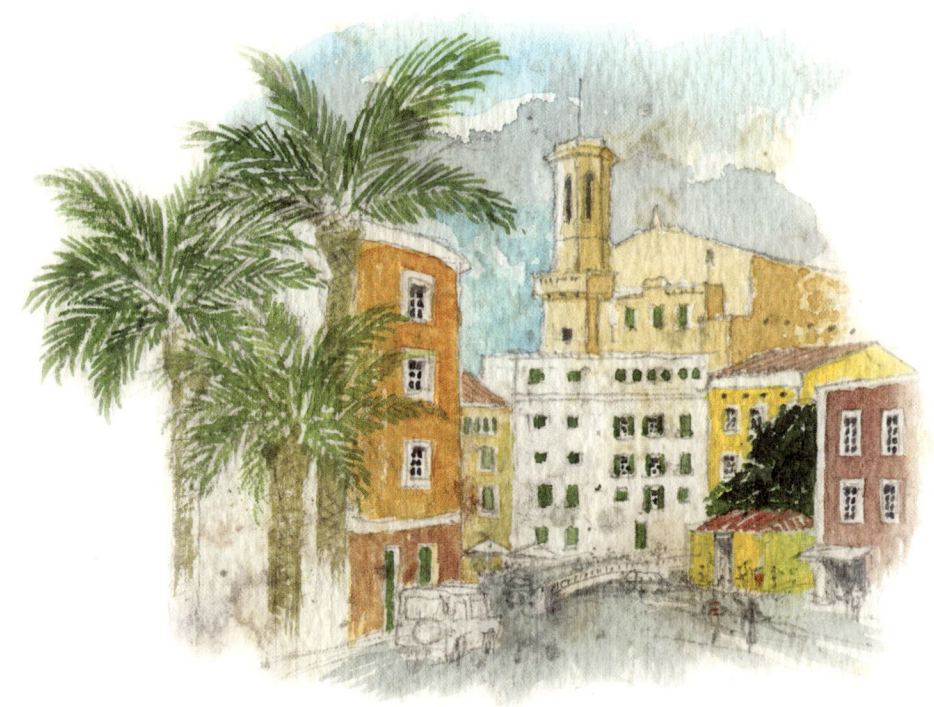

Menorca Sketchbook

Tre Cavalli, sculpture donated by Nag Arnaldi in 2015, takes pride of place at the entrance to the Church of El Carme.

First published in 2021 by

Talisman Publishing Pte Ltd
talisman@apdsing.com
www.talismanpublishing.com

ISBN 978-981-14-5056-3

Paintings © Graham Byfield
Text © Marcus Binney
Editor: Lorraine Ure
Designers: Stephy Chee, Wong Sze Wey
Studio Manager: Janice Ng
Publisher: Ian Pringle

All rights reserved. No part of this publication may be reproduced or transmitted in any form or by any means, electronic or mechanical, including photocopying, recording or any information storage or retrieval system, without permission from the publisher.

Printed in Singapore

Menorca is one of the most magical of all the Mediterranean islands. The island's south coast beaches, its wild northern coastline, its climate, the light, the rich mosaic of natural habitats that teem with life, wildflowers, song birds, butterflies all add up to make this perhaps the most beautiful place we've ever seen.

Across the world the very fabric of life is becoming threadbare. Nature is hugely resilient, and life bounces back astonishingly quickly if we give it space. Modest amounts of philanthropic funding in the right hands can bring about long lasting and transformational change. The Menorca Preservation Fund aims to bring together people who love this beautiful island, with the heroes who are working day and night to protect and restore it.

This marvellous book is a step in the right direction by highlighting so many beautiful, and even in some cases relatively unknown, parts of the island.

We are delighted that a percentage of the sales of this book in Menorca will be given to the Fund to help with their ongoing and future projects on the island.

Mr. BEN GOLDSMITH
Co-founder of the Menorca Preservation Fund

Mrs. REBECCA MORRIS
Director of the Menorca Preservation Fund

Menorca Sketchbook

Paintings by Graham Byfield
Written by Marcus Binney

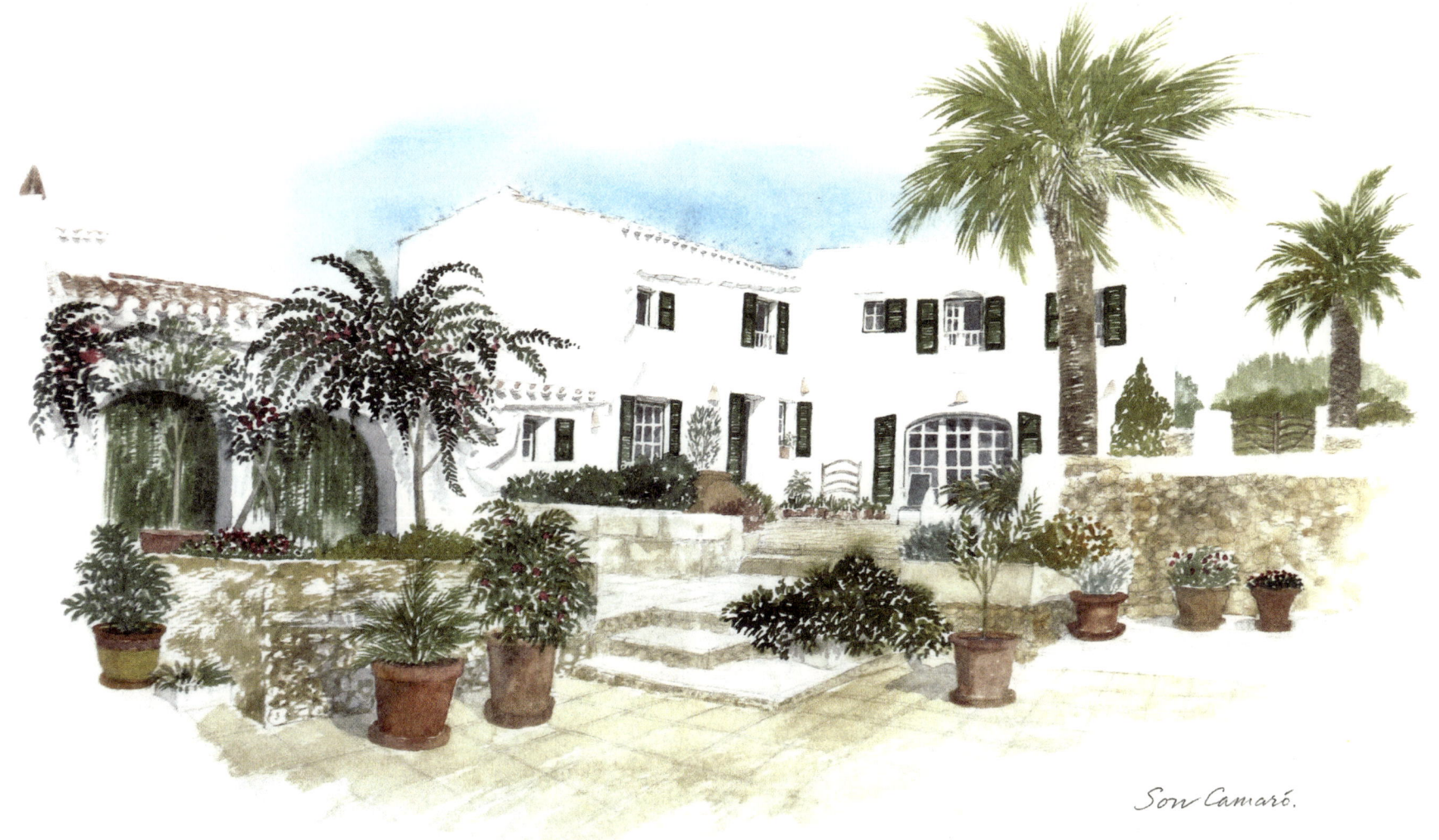

Son Camaró.

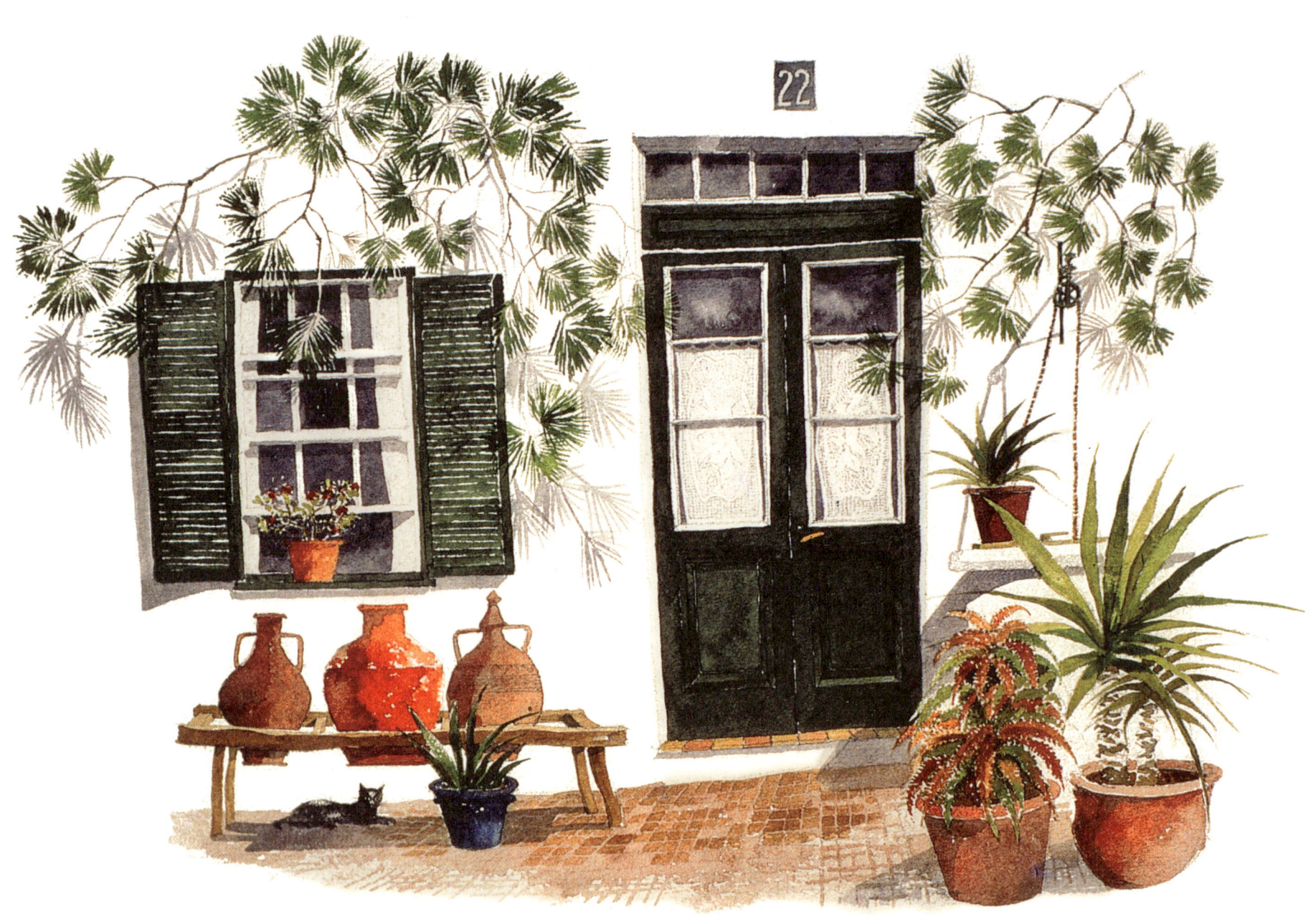

Contents

Discovering Menorca	Page 6
Mahon	Page 18
Ciudadela	Page 26
Villages	Page 36
Countryside	Page 48
The Coast	Page 60

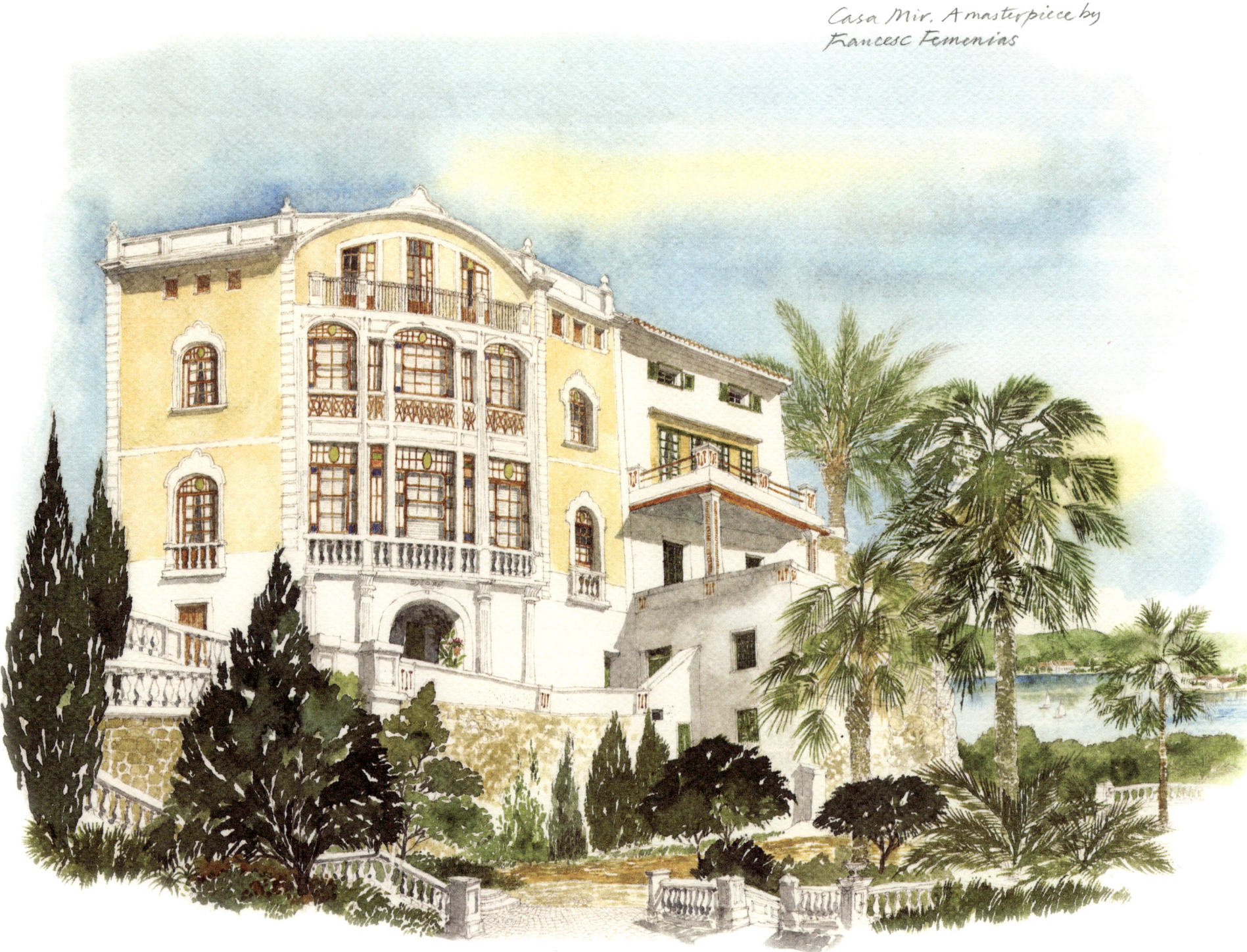

Casa Mir. A masterpiece by Francesc Femenias

Discovering Menorca

The island of Menorca is a treasure-house of architectural riches great and small spanning more than four thousand years. Despite damage and destruction through repeated invasions, occupations and civil war, an astonishing amount remains for those with the time and spirit of adventure to seek it out. Much also survives largely unaltered, even if occasionally decayed, and the losses and wounds from voracious modern development, so frequent around the Mediterranean, have been relatively contained. The patchwork of stonewalled fields cloaking hillocks and larger hills and the prettily painted town houses along winding lanes in the older towns offer a pervading sense of harmony and contentment.

Though little more than fifty kilometres long, the island has two bustling "capital cities" (Ciudadela and Mahon), one ancient, one more modern, a cathedral, proud churches and monasteries, town halls, opulent town palaces and mansions, ornate market buildings and attractive plazas to congregate, sit in and soak up the atmosphere.

The landscape of Menorca may seem tame by comparison to the romantic mountainous terrain of its sister island Mallorca, but its coastline is a marvel of long sandy beaches and luminous pine-fringed coves with a turquoise sea to match the Caribbean. The dry stone-walled fields conceal to the last minute some of its most remarkable landscape features, from the ravines (barrancos) or canyons which descend hidden from view through fertile fields to secret bays and creeks, often with a single enchanting white-walled fisherman's hut presiding over a marine paradise.

Menorca has its own distinctive form of farmhouse to be seen all over the island, often on a crest to catch the breeze. The entrances are marked by twin gate piers and white-topped walls. Quite a number can be visited on the spur of the moment, as many of the farms sell their own delicious cheeses from the farmyard.

The roof gables of the farmhouses are usually on the long side, giving them a distinctive silhouette. It's an architecture of

Menorca resembles a huge open-air museum, with an abundance of settlements dating back to the Bronze Age around 2000 BC. The Naveta des Tudons is the finest example of an ancient burial chamber, shaped like an upturned boat.

Fortress of Santa Agueda. Last stronghold of the Moors, prior to the defeat by Christian forces in 1287.

simple volumes, every one slightly different with the roofs sometimes continuing down over lower side buildings in one sweep.

Menorca also has an impressive group of seigneurial houses built by the larger landowners, often painted an oxblood red. Typically these may have balustrade terraces, trios of arches fronting shady loggias and a triangular pediment like that on a temple. Fine specimen trees stand out at a distance shading the gardens. My favourite is Binissafuller near San Luis, with a vast surging eyebrow-shaped gable over the entrance front. It is built on a square plan, powerfully baroque in style but 19th century in date.

Menorca is rich in prehistoric remains dating as far back as 2,300 BC. As you travel around the island you repeatedly see signs announcing "talayots" – megalithic settlements dating from the 2nd millennium BC. Many have a "taula", consisting of two large, carefully-balanced stones forming a capital "T" and which take their name from the Catalan word for table. There are thirty-two talayots on the island, with the largest settlement to be found at Trepucó. In addition, there are "navetas", prehistorical burial chambers shaped like the upturned hull of a ship. The best-preserved is the Naveta des Tudons, near to Ciudadela.

There is also an exceptionally well-preserved and evocative prehistoric settlement at Son Catlar (1000-700 BC) surrounded by a 900-metre Cyclopean wall, still very much intact. A walk around it provides a view of the towers and entrances before inspecting the extensive remains within, including four talayots and a taula.

Following the Punic Wars with Hannibal, the Romans occupied Spain and trade thrived but was increasingly hampered by pirates based in the Balearics. The Romans invaded Menorca in 123 BC, nearly 70 years before Caesar landed in Britain in 55 BC.

In Roman times the island was famous for its "stone-slingers", deadly accurate fighters who were as effective as the English longbowmen of the Hundred Years War. Their ability was to deliver "David against Goliath" blows to an enemy one hundred yards and more away.

When the Moors invaded Spain, they took Menorca in 903 AD, giving the island its Arabic name (Menurka), and absorbing it into the Caliphate of Cordoba, in which it remained for nearly four centuries. On the third-highest hill in the island are the remains of the Castle of Santa Agueda, their last stronghold, a climb equally rewarding for the view. The walk takes an hour up the old paved road. Menorca's last Arab inhabitants left in 1287 following the reconquest of the island by Alfonso III, King of Aragon and Count of Barcelona. Though the King ordered the destruction of the castle, time has taken the greater toll, but still offers the visitor the most extensive Moorish remains on the island.

Inland towns were established at Alayor, Es Mercadal and Ferrerias, each on rising ground with a prominent church encircled by narrow winding lanes.

In complete contrast are Menorca's three planned towns, built on grid plans with straight streets. The first is San Luis laid out by the Conde de Lannion after the French took the island from the British in 1756. It is dominated by the grand two-stage façade of the baroque church begun in 1758, an echo of the stately church of the Sorbonne in Paris.

Next came Georgetown (named in honour of the young King George III of England) laid out by the British Colonel Patrick MacKellar in 1764 during the second British occupation. Later renamed Villa Carlos after the Spanish King Carlos III, it is now called Es Castell. The plan is that of a Roman castrum with straight streets leading to a large central parade ground with barracks on three sides, one named after the French Duke of Crillon. On the other sides are the 1786 Town Hall and the Spanish military museum, formerly the barracks of Cala Corb.

The third planned town is San Clemente, laid out by orders of the Bishop of Menorca in 1817, again with straight streets and a handsome Gothic Revival church built in 1888.

Until the 20th century Menorcans lived in houses rather than apartments, similar to terrace houses in Britain, and row houses in North America. In Mahon these houses are uniformly whitewashed while in Ciudadela most are painted in pretty pastel colours, often with a smart white band forming a frame to both windows and the whole house.

The houses are built of the local limestone, sometimes cut from the rock below the plot on which the house stands. There are usually submerged cellars, aired by slits at pavement level, which may also serve as hatches for goods to be taken down to storage. These cellars and sometimes the ground floor rooms are vaulted in stone to keep them cool. Water was collected from the roof and terraces and channelled down into a "cisterna".

Mahon's finest mansion, Ca n'Oliver, is now regularly open to the public after long years as a furniture repository. The star turn is the magnificent staircase hall rising the full height of the house. The flights of steps divide and rejoin in dazzling succession, wrapping round three walls with galleries on the fourth, all with balustrades as intricate as black lace and panoramic murals on the walls. Be sure to climb the prospect tower and look down on numerous roof gardens and patios contrived in every available space. These towers were built to give early warning of arriving vessels.

In Ciudadela, the Casa Olivar opposite the cathedral is also open to visitors and contains two first-floor rooms with delightful painted cornices, one of exotic birds, the other with a procession of animals ranging from a flea to an elephant.

On the east side of the Plaza del Born stand twin palaces, an echo of those overlooking the Place de la Concorde in Paris. To the left are the twin pavilions of the Torresaura Palace with a handsome and very French portal with curved pediment carved with a splendid coat of arms. To the right is the single pavilion of the Salort Palace.

Talati de Dalt. One of the best preserved prehistoric settlements in Menorca. Dating back to the Bronze Age, the Talayotic period (1300 BC to -123 BC) lasted well into the Roman times.

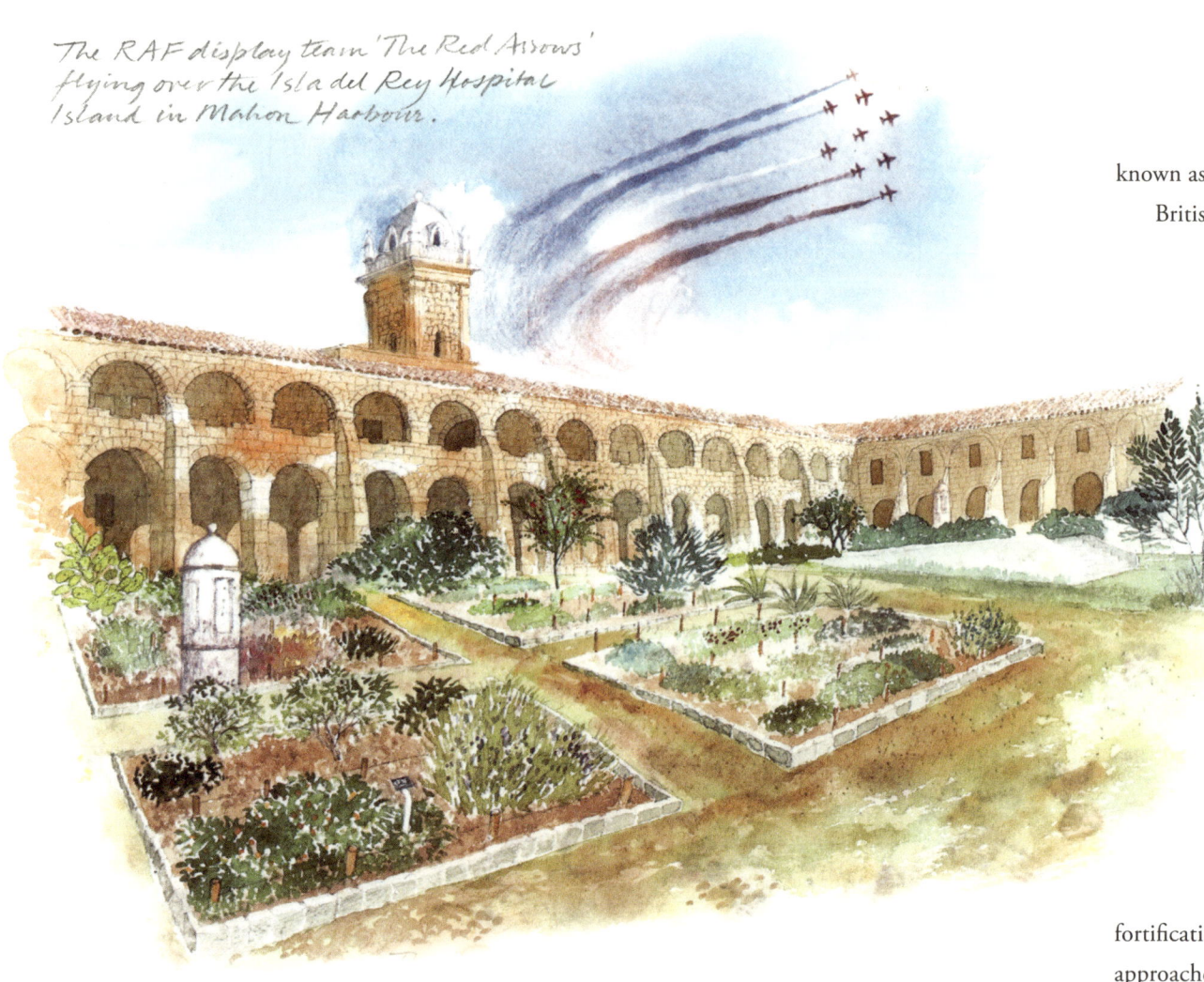

The RAF display team 'The Red Arrows' flying over the Isla del Rey Hospital Island in Mahon Harbour.

known as Saint Philip's Castle. On taking Menorca in 1708, the British immediately set about transforming it into a modern artillery fortress with three double ravelins [salients beyond the main ditch], counterguards and outlying redoubts and small forts. Had it survived complete it would be as impressive as many of the great geometric fortifications by Louis XIV's renowned military engineer Vauban.

Instead, when the Spanish and French wrested the island for the second time from the British in 1782, the Spanish King Carlos III insisted it should be dismantled stone by stone so the British could never regain their foothold. Spanish engineers set about blowing up the labyrinth of tunnels under the fortifications but ran out of gunpowder before they could complete the job.

Today, the main surviving element of the British fortifications is the beautifully restored Fort Marlborough, approached along the peaceful cove of San Esteban, with pretty well-kept houses.

It was built between 1720 and 1726 to prevent the enemy positioning batteries to attack St Philip's Castle. The fort is surrounded by a broad dry moat and was defended by eight cannons, four defending the landward approach and four the mouth of the cove. You enter the fort along a slowly rising tunnel from the cove to emerge in a paved gallery unexpectedly running around the outside of the moat, part cut into the natural rock, part walled and vaulted.

The War of Spanish Succession had pitched those in favour of a French Bourbon heir to the Spanish throne against those who

The doors of the Salort Palace, also open to the public, were wide enough for carriages to pass through and allow passengers to disembark in the shade. The floor is paved with scored tiles so horses do not slip. Sash windows provide borrowed light into rooms on other the three sides of the staircase hall. One of these rooms is a lying-in chamber, the 'room of life and death', where visitors came to congratulate mothers who had just given birth, or look in and wave at relatives who were sick, or indeed pay their last respects as they filed past a coffin.

To protect the mouth of the harbour at Mahon the Spanish Kings embarked in 1552 on an ambitious star bastion fortress

supported an Austrian Hapsburg successor, including Britain and Catalonia. British and Dutch forces took Menorca in 1708 and were welcomed as liberators. The Peace of Utrecht in 1713 ceded Menorca to Britain.

The enlightened and entrepreneurial British governor Richard Kane made a lasting mark on the island during his 30-year rule. Though the British, as Protestants, were held to be heretics by the Catholic clergy and nobility, Kane respected the laws, traditions and religion of the island. Menorca prospered, especially thanks to the opportunity to trade with the British colonies in North America and the Caribbean. Kane is recognised for his contribution to improving the agriculture of the island, introducing cattle and crops, and for organising the construction of the first road across the island, linking Mahon and Ciudadela, to facilitate the movement of both troops and populace.

Following the capture of Menorca in 1708, Admiral Sir John Jennings, Commander of the Mediterranean fleet, ordered the construction of a naval hospital without waiting for Admiralty approval and completed the project for a third of original estimate. This brought him no official thanks. Although he and his brother officers paid for much of the work themselves, they only obtained partial repayment by petitioning Queen Anne. The hospital is situated in the centre of Mahon Harbour, on an islet known as Isla del Rey, and remained almost continuously in use as such until 1964 (in latter years for Spanish Army personnel, their families and conscripts needing medical attention). In its heyday it boasted 1,200 beds.

Abandoned for forty years, it began to be rescued from dereliction in 2004 by an enterprising band of Sunday morning volunteers, both Menorcans, British and others living on the island. They continue their work to this day, led by an energetic and enthusiastic former Chief of Staff of the Spanish Army, General Luis Alejandre. He explained, "When I retired to my native Menorca and saw the terrible state of the hospital, people said to me 'You are a general so why don't you do something about it?'", so he took them at their word. It can now be visited by boat every Sunday morning throughout the year, and more often in the high season.

Another great landmark for the Isla del Rey is the imminent opening in 2020 of a prestigious modern art gallery in an adjacent building, plus a Centre of Interpretation for the whole Port of Mahon located on the first floor of the hospital building.

Close to the harbour entrance, there is another remarkable public work, a lazaretto or quarantine station, which operated

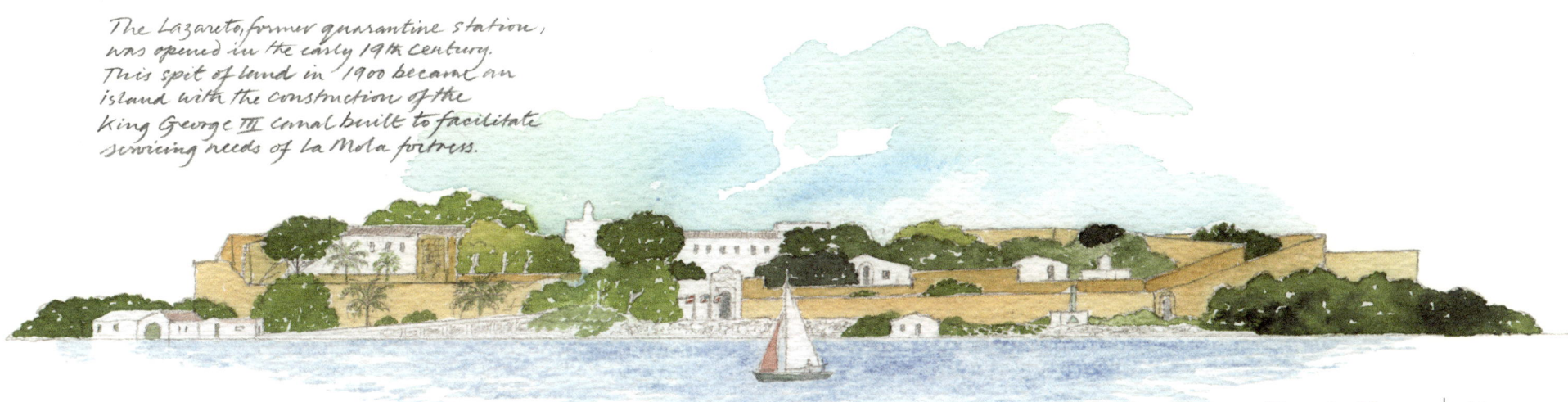

The Lazareto, former quarantine station, was opened in the early 19th century. This spit of land in 1900 became an island with the construction of the King George III canal built to facilitate servicing needs of La Mola fortress.

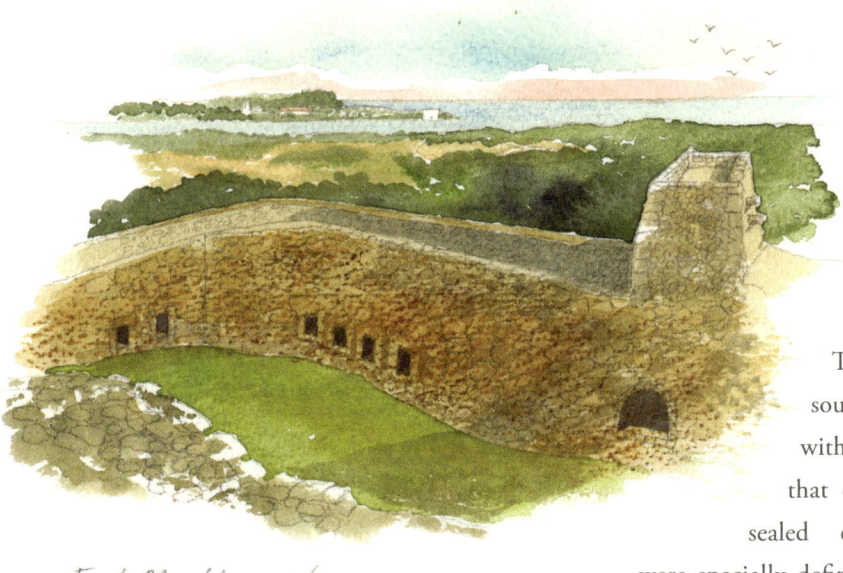

Fort Marlborough, celebrating its 300th Anniversary in 2020. Named after Sir John Churchill, Duke of Marlborough.

The Chapel on the Lazareto was designed to resemble a small temple. It enabled the priest to administer the host without fear of contamination.

between 1817 and 1917. The entire complex is encircled with a double wall. There are gates on the south and west and, within, further high walls that divide the layout into sealed compartments. There were specially defined areas for crew and passengers and for those who were infected or suspect. The cargo of each ship was kept separate. Techniques used for purifying goods included simple exposure to the atmosphere, exposure to fresh dew, sinking laden vessels in sea water, and also fumigation. A lookout tower stands in the centre raised on high arches. A delightful feature is the chapel in the form of a little glazed "temple" in a circular enclosure surrounded by low-walled pens rather like theatre boxes. Here the inmates could watch the elevation of the host across a strip of "no man's land".

Menorca mainly supported the Republican side in the Spanish Civil War while Mallorca sided with Franco. Terrible damage was done to the interiors of churches, so much so that in many cases only vestiges of their ornate altars remained – though the noble architecture of Gothic vaults and classical domes survived better. Having fought on the losing side, Menorca was for long starved of investment until airborne tourism began and great 'slab' hotels were built above a number of the best beaches. By the early 1970s there was mounting local concern about the potential spoliation of the island, and slogans were painted on numerous building proclaiming anti-urbanisation sentiments.

There was also a rash of villa construction around the coast. New houses in those days had to adhere to a strict planning code with white walls, loggias and red tiled roofs intended to harmonise with the landscape. The aim was to create a sense of place and a Mediterranean identity. It was not so popular with some of the architects who would have preferred the clean geometry of modernism. Two interesting examples are the resort village of S'Algar, laid out by the Sintes family with handsome avenues of palm trees now grown to maturity, and Binibeca Vell, an imagined recreation of a traditional fishermen's village with all-white roofs and walls. Though too cute for some tastes, it has a charm and consistency and its changing levels and twisting lanes are an invitation to explore.

Today there is a strong "ecological lobby" in Menorca and the island became a UNESCO Biosphere in 1993. Local organisations such as the influential Menorca Preservation Fund, and also GOB (the Balearic group which defends ornithology and nature) keep a close watching eye on current and future development proposals.

Menorca has an impressive circle of fifteen coastal defence towers, twelve of which were built by the British during their

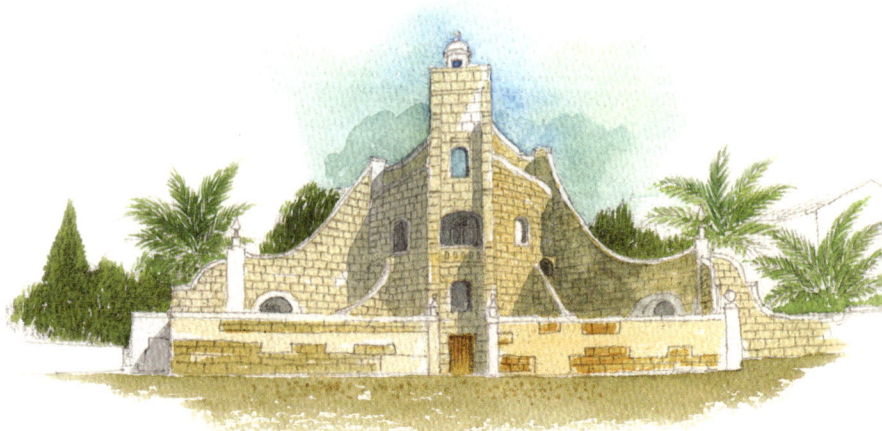

The elegantly buttressed Watchtower, offering all-round vision of the whole area, including within the double walls.

12 | Menorca Sketchbook

third and final occupation led by General Stuart (1798 to 1802), protecting the island from waterborne landings. The Royal Navy had learnt how effective a single artillery tower could be in Corsica at Mortella where one tower had repelled a naval landing for two days, damaging British ships whilst the tower remained largely intact. Hence the introduction of Martello towers familiar around Britain as well as Menorca.

The new towers were built under the direction of Captain d´Arcy, in charge of the Royal Engineers in Menorca at the time. Each tower had two floors and a gun platform with a magazine on the ground floor. On the roof was a furnace used for heating cannon shot to red-hot heat.

Later, the Spanish also constructed a number of large gun towers along the shores of Spain, the Canary Islands and the Balearics. Two were built in Menorca and supplied with huge Vickers guns (one of these can be still be visited at the La Mola fortress).

Kane's Road, built by the first British Governor, provides a peaceful and fascinating alternative to the relentless traffic on the main road from Mahon to Ciudadela. It branches off left on the road to Fornells quite soon after you leave the end of the harbour, running all the way to Es Mercadal. It originally went as far as Ciudadela. You may encounter little more than a dozen cars along its whole length. It is framed by dry-stone walls, some in good repair, others less so. Every few hundred yards a pair of gate piers announces a whitewashed farm or seigneurial manor house, including Son Bonaventura, former home of Governor Richard Kane. At Alayor the road passes the monumental town cemetery with numerous mausoleums and tombstones packed into a succession of courtyards that are all laid out with geometric

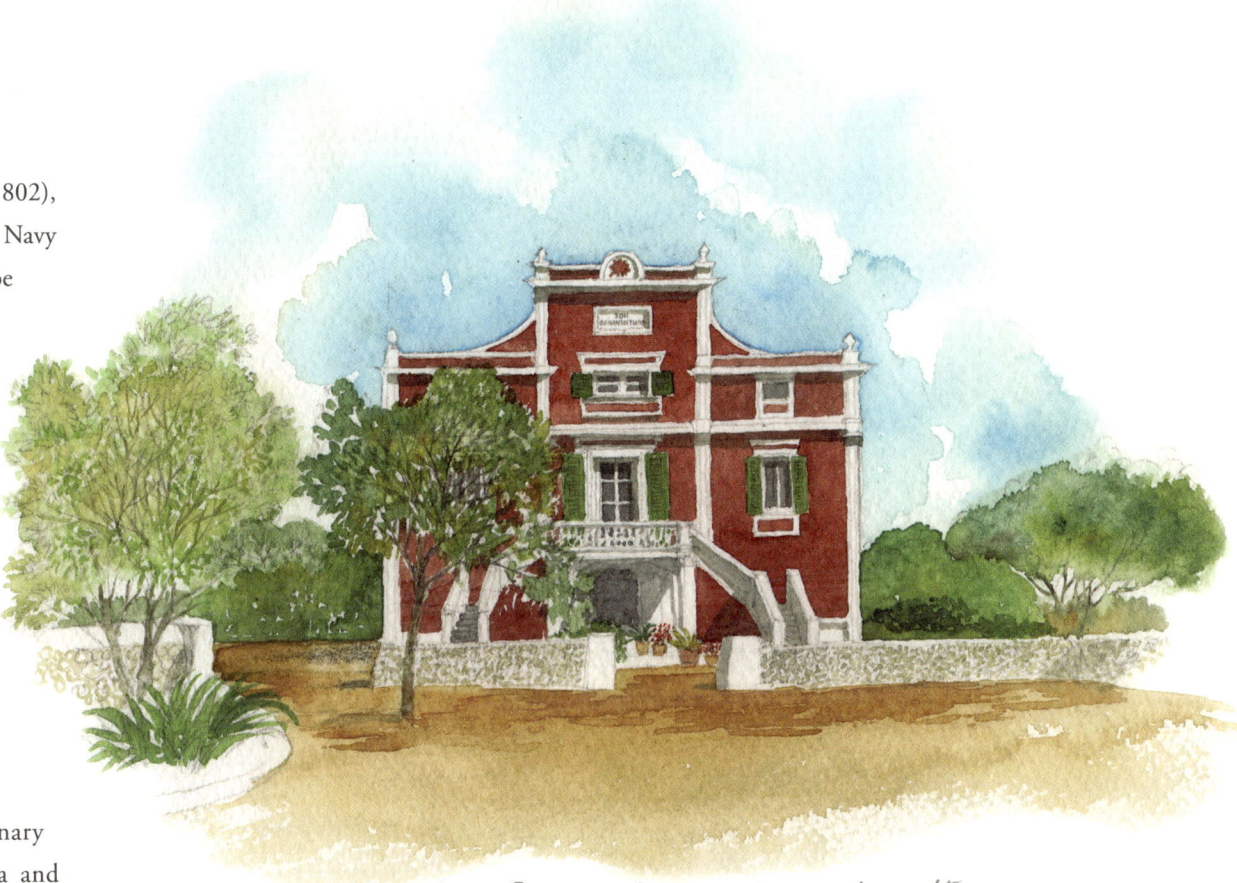

Casa Bonaventura, mid-way down the Kane's Road, a country house of the first British Governor.

precision. There is a handsome cemetery outside every town, but this is one of the most beautiful and resonant.

Just opposite, a stone-walled road, Es Cos, straight as a lance, leads to the centre of Alayor. This was the venue for an annual horserace and the judge's box is set on top of the wall like a pulpit. A little further on to the left is a pair of monumental gate piers tall enough to guard an Egyptian temple but sheltering nothing more than an overgrown orchard. Beyond this lies Kane's bridge, the oldest in Menorca, set low with medieval pointed arches and triangular refuges at the sides for people to stand while heavy carts passed and for spot-checks to be made by the authorities.

Admiral Farragut, whose father was born in Menorca, became the first-ever Admiral in the U.S. Navy. He visited Menorca during his service.

The harbour of Mahon is worth exploring both by boat and by land. The glass-bottom boats do an absorbing tour, first providing an intriguing glimpse of the former British naval base, part of which is an octagonal island, Isla Pinto, constructed so that as many as eight ships could be simultaneously refitted and careened alongside. The original low buildings and clock tower with its "marine helmet" dome remain, together with various dockyard buildings. It is still in use by the Spanish Navy.

The boat trip continues past an impressive series of grand villas in manicured gardens, passing an enchanting white-painted villa which appears to be floating on the water and linked to land by a narrow causeway. Also on the north side you will spot the 19th century Anglo-American Cemetery and the small French one, both set peacefully by still waters.

Towards the harbour entrance, you come to the great 19th century Spanish fortress of La Mola. This was constructed on a colossal scale with masonry worthy of a cathedral cloister. Intriguingly, it was built under pressure from the British Prime Minister Lord Palmerston. His concern was that the French conquest of Algeria provided France with a naval base to match Toulon, and if they took Menorca too, they could deny the Royal Navy access to the eastern Mediterranean. By then, the Spanish had already destroyed St Philips Castle following their reconquest in the 1780s, leaving the island virtually undefended.

A fascinating feature of the Menorca landscape is the stepped pyramids found in fields across the island with a large concentration north east of Ciudadela towards Punta Nati. At first encounter they look like another form of ancient or prehistoric remains. They are built with dry stones and, where people have tried to climb them, the stones have been loosened and look like heaps of rubble. They are to be numbered in dozens if not hundreds and many retain the crisp edges which create their amazing silhouettes. They are of three, four and even seven stages, circular but sometimes with a square base.

Approaching close, you find a low doorway and, on entering, you are in a space like an igloo built of neatly-laid stone. These are sheep shelters. The form appears to be inspired by the ancient Egyptian step pyramids, most obviously the mighty stepped pyramid of Djoser, built as a tomb for the pharaoh, which is of six tiers and four sides.

These unusual landmarks are the product of the landscape craze of the early 19th century. This began in Britain and Ireland in the 18th century where landowners built temples, follies and "eye-catchers" to ornament their parks. In Menorca, landowners embarked on a competition to outdo their neighbours in the number and size of stepped pyramids they built.

Another fascinating group of buildings is the cluster of summer houses in the surroundings of Alayor. These are a

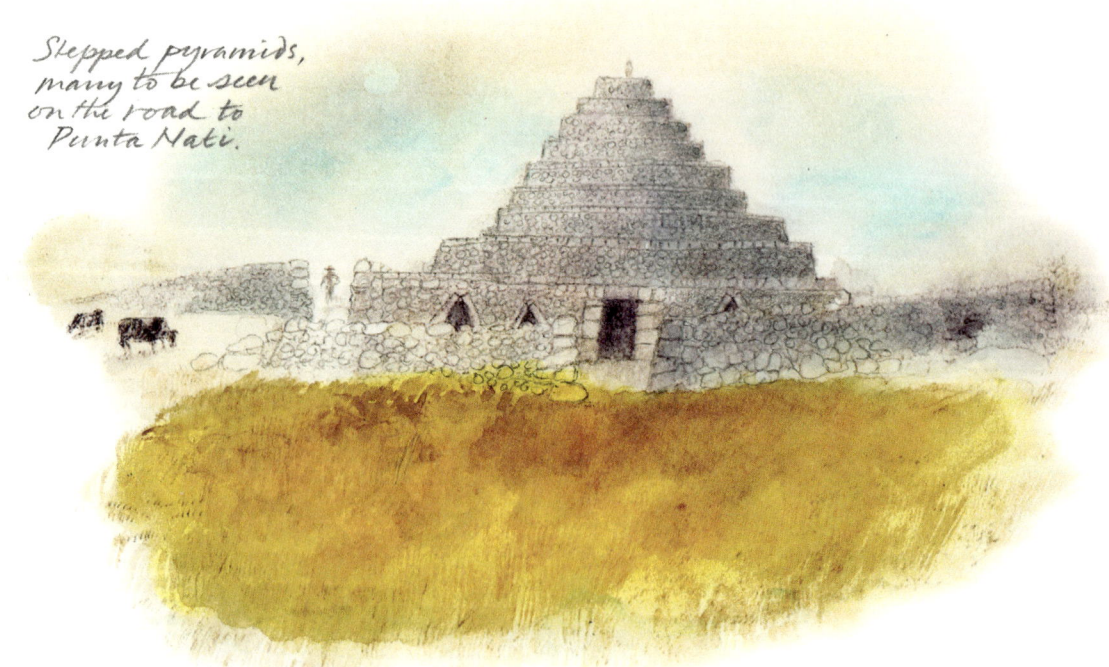

Stepped pyramids, many to be seen on the road to Punta Nati.

14 | Menorca Sketchbook

selection of charming pavilions built as summer retreats by Menorcan workers returning from a period of emigration to Cordoba in Mexico where they admired them. Each stands proud in a garden plot and they run the whole gamut of styles: Baroque, Palladian, Gothic Revival, Swiss Chalet and Art Deco. Quite a few can be seen off the ring road to the south of Alayor, proudly displaying the date of their completion. Examples are the delightful blue l'Orgue (1896), La Giralda (1932), Laracke (1912) and another further to the south dated 1941.

There is also another enchanting group of pavilions, this time former banqueting houses, to be found on the banks of the upper harbour creek at Ciudadela near to the gracious 19th century iron bridge. They can be enjoyed to excellent advantage from the outdoor tables of some of the nearby restaurants. The pavilions are set in baroque-style terraces and walled gardens. They were built to watch horse races, but the architect Josep Martorell told me that the men of the town would frequently repair there for long lunches with friends to barbecue the fish they had just caught. Today many have become bars and nightclubs.

The creeks north and south of Ciudadela also retain an attractive group of pretty and mainly art nouveau seaside villas, petite versions of those in the fin-de-siècle resorts of the Normandy coast. One good group is at Sa Caleta, while another is along the headland on either side of the Sa Farola lighthouse.

Mahon and its outlying villages have their own distinctive group of whitewashed small houses, proudly bearing dates from the 1870s and through the First World War when Spain was neutral. Typically, these are single storey with a central front door and maybe a balustrade.

As well as the cathedral and monasteries the island has numerous smaller churches. In Ciudadela, the 1667 Capella

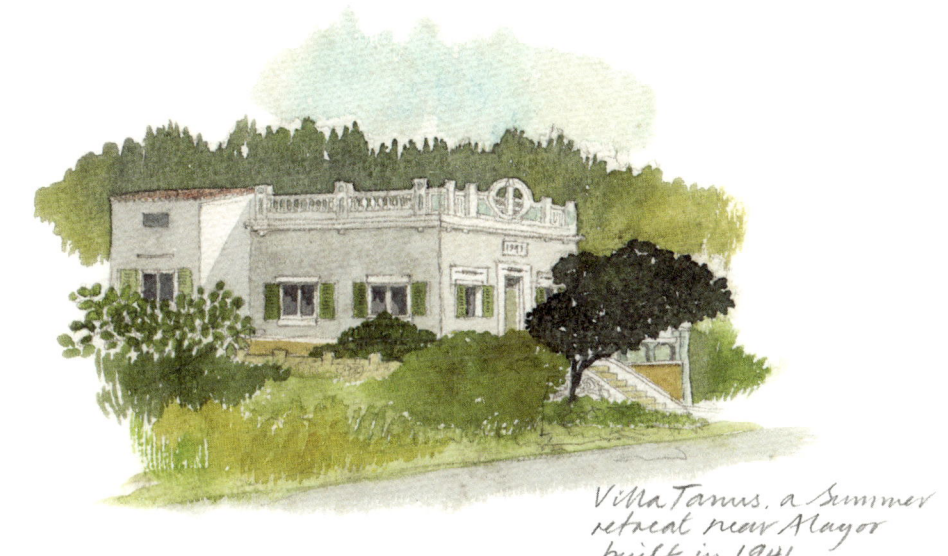

Villa Tanus, a summer retreat near Alayor built in 1941.

L'Orgue (1896) stands out as you enter Alayor with its distinctive blue colour, which adorns an old organ loft. Now home to a distinguished landscape gardener

del Sant Crist is a marvel of a small baroque church with a richly carved portal and domed interior, while nearby is the Iglesia del Roser with a trio of columned doorways and a richly carved vault.

In Mahon the Byzantine-style church of the Conception, in the Cos de Gracia, is domed and was erected by the British for the large Greek colony present around 1749. Hence its distinctive form – not built as a Latin cross with a long nave but as a Greek cross with four equal arms and a central dome.

It is worth keeping an eye open for any work by Francesc Femenias (1870-1938), the first professional architect to practise

Discovering Menorca | 15

in Menorca in modern times. He was highly accomplished, sophisticated and inventive and his work looks both forward and back. He designed the graciously curved art nouveau Casa Mir dominating the Plaza de la Conquista and the windy steps leading down to the port, and also the iconic Fish Market. Another handsome example overlooks the Plaza del Principe in Mahon, the Casa Francisca Martorell of 1918, with a trio of Venetian Gothic arches and belvedere tower. Femenias also did a series of country villas with distinctive towers, arches and loggias – one is the Casal de Llumena Nou dating from 1915, seen from the main road as it approaches Alayor from Mahon. He was also the architect of one of Menorca's best industrial monuments, the now disused factory Fabrica Codina in Calle San Manuel in Mahon, and the first electric power station "Eléctrica Mahonesa" on the harbour, still brandishing its charming "Electra" statue on the roof despite being bombed during the civil war.

If you want to explore Menorca in depth, a useful tool is a widely-sold folding map "Menorca Reserve of the Biosphere". It shows all the country lanes, coastal towers and lighthouses, as well as many of the archaeological sites. It also marks and names almost every farm house.

There are many other modern guidebooks and specialist maps widely available, including the "Guide of Cami de Cavalls", showing twenty itineraries for discovering Menorca on foot or horseback along the restored paths which encircle the island, and much other interesting information. Indeed, every year new books appear on Menorca's heritage, history, culture, cuisine, flora and fauna.

GRAHAM BYFIELD, the artist, and I, MARCUS BINNEY, the writer, hope that this one will certainly whet your appetite to explore further.

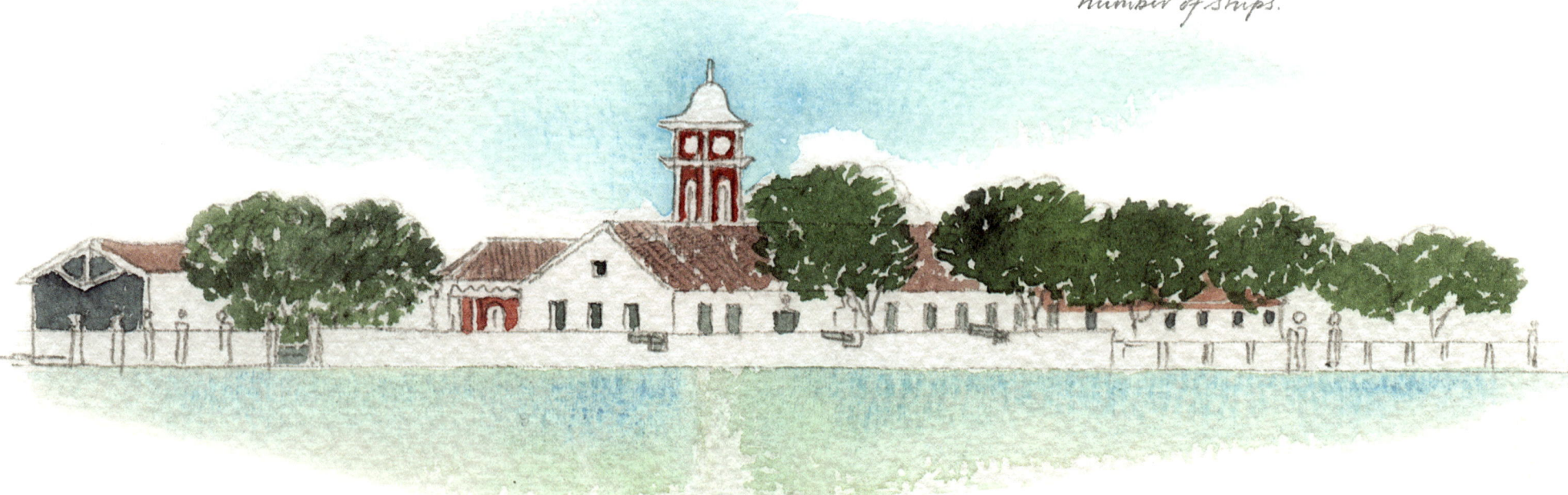

Isla Pinto, part of the Naval Base, originally built by the British, has eight straight sides for simultaneously refitting a number of ships.

16 | Menorca Sketchbook

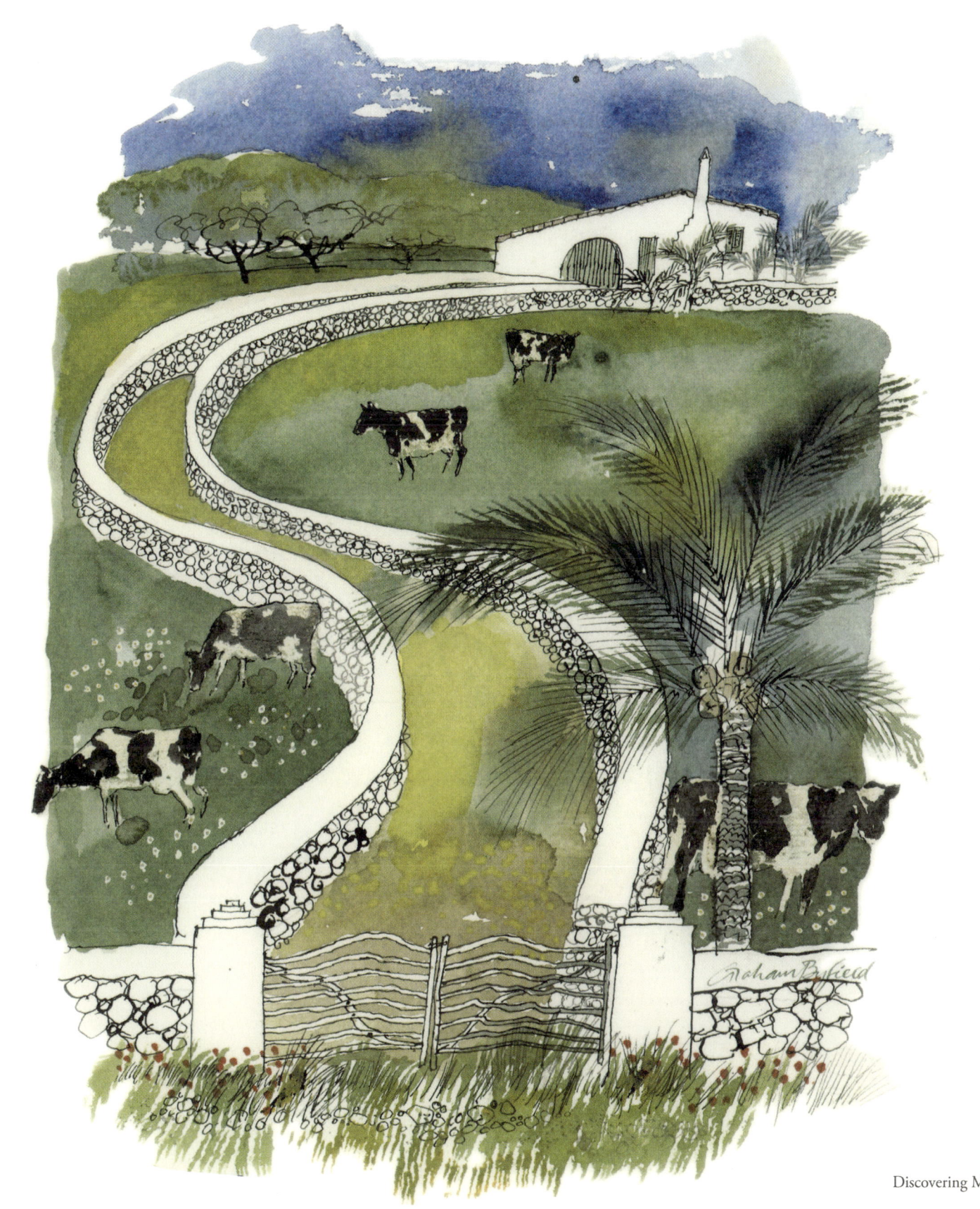

Discovering Menorca | 17

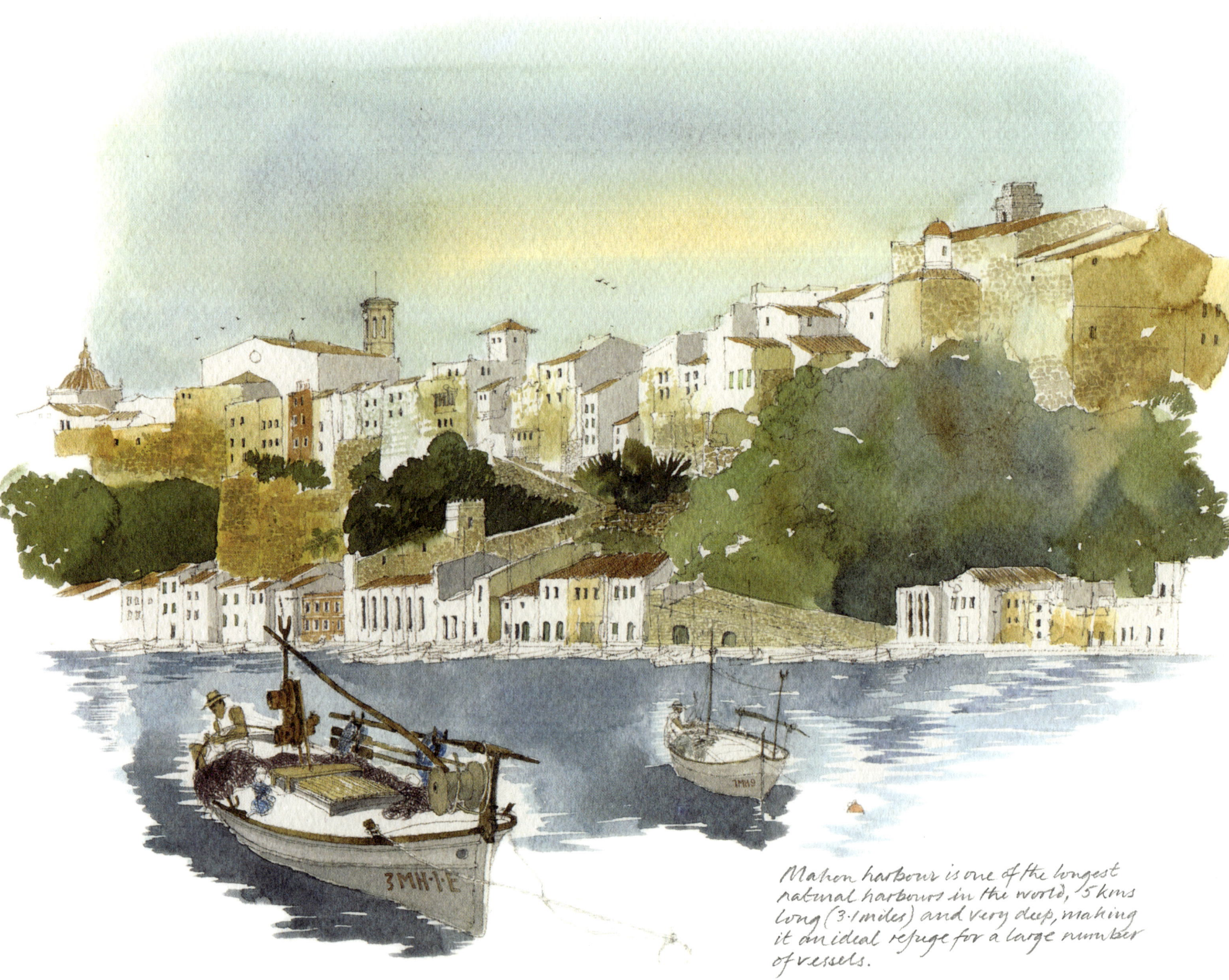

Mahon harbour is one of the longest natural harbours in the world, 5 kms long (3·1 miles) and very deep, making it an ideal refuge for a large number of vessels.

Mahon

The city of Mahon is best seen from the harbour. It stands proudly on heights rising almost sheer from the quayside. At the western end the monastery of San Francisco stands magnificently against the sky. The old road along the waterfront was transformed into a stylish promenade in the 1980s with a new paved walkway and moorings for a variety of yachts, fishing boats, ferries and the occasional cruise ship.

There is a lovely view of the Naval Base with a glimpse of the stately house known as Golden Farm or San Antonio on the hill behind, while the old British-built Royal Naval Hospital (1711) stands conspicuously on the Isla del Rey, floodlit at night. Restaurants, bars and boutiques abound. A grand ascent to the town is via what is now known as the Parque Rochina, conceived in 1914 by Francesc Femenías but not created until 1945 by Josep Claret, with a snaking corniche bisected by a grand balustrade stairway arriving just below the imposing Santa Maria church and main shopping streets.

To the left is the Carmen church and in its adjoining cloister is a lively food market. Beside it is the delightful fish market (1927, again by Femenías), still thriving and now also offering a tempting array of tapas, wines and beers. One stall will cook the fish you buy in the market on the spot.

As you walk through the town, note the exuberant Town Hall, originally built in 1613 and modernised in 1789, and worth entering to enjoy some historic framed views of the town and also its imposing council chamber. Its clock was brought from England in 1731. Also note the Santa Maria church, with its remarkable organ, the safe delivery of which was facilitated by Admiral Lord Collingwood in 1810. Nearby, the arched medieval gateway of San Roque is the sole remaining element of the city walls. At the top of the town is the large Plaza de la Esplanada. Behind the war memorial, you can glimpse the oxblood red British barracks dating from 1765. Several of Mahon's finest mansions line the Isabell II street, the most prominent being the Palace of the Military Governor with its gracious arcaded courtyard opening off the street. At the end is the restored Church and Monastery of San Francisco and its cloister, now housing the beautifully-curated Museum of Menorca.

Throughout the town, observe the dark green paint of the window shutters and the numerous handsome front doors with art nouveau flourishes. Many first-floor balconies have pretty ironwork. Note too the prominent bow windows, (known locally as "boinders") and a legacy of the British occupation.

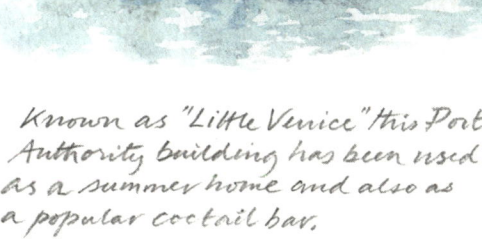

Known as "Little Venice" this Port Authority building has been used as a summer home and also as a popular cocktail bar.

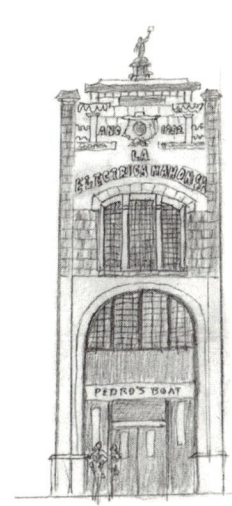

Menorca's first power station, by Francesc Femenías. Note the little statue of "Electra" on top.

Old bathing station, especially for the ladies of Mahon, away from prying eyes. Curiously, however, it is overlooked by the Naval "Base"!

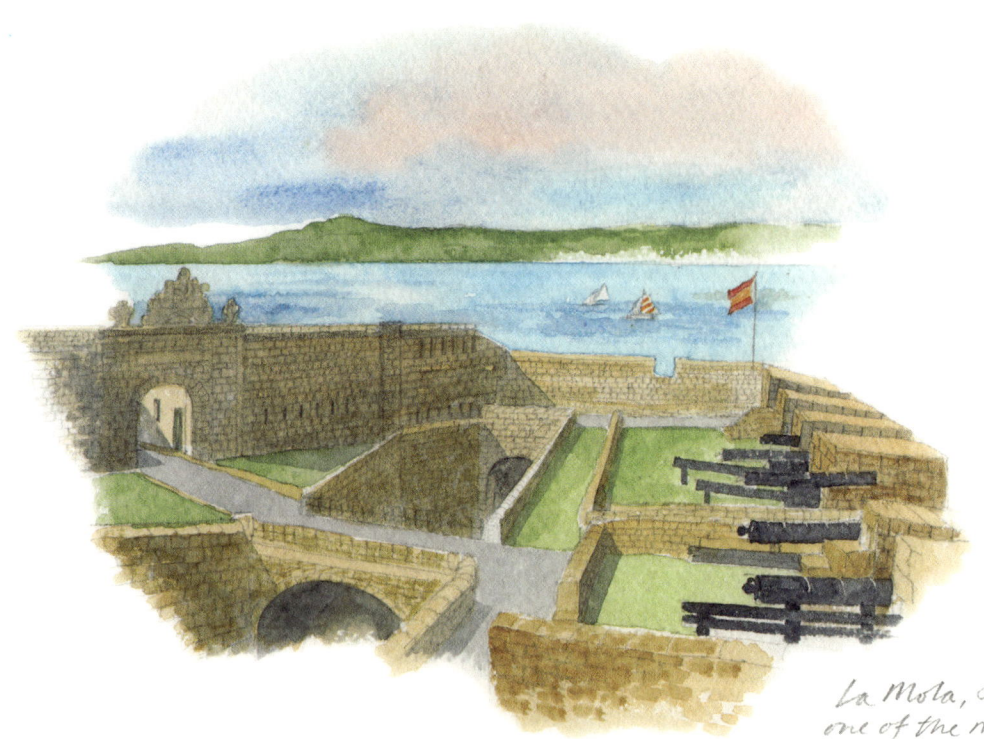

La Mola, completed in 1875, and one of the major European fortresses constructed in the 19th century.

20 | Menorca Sketchbook

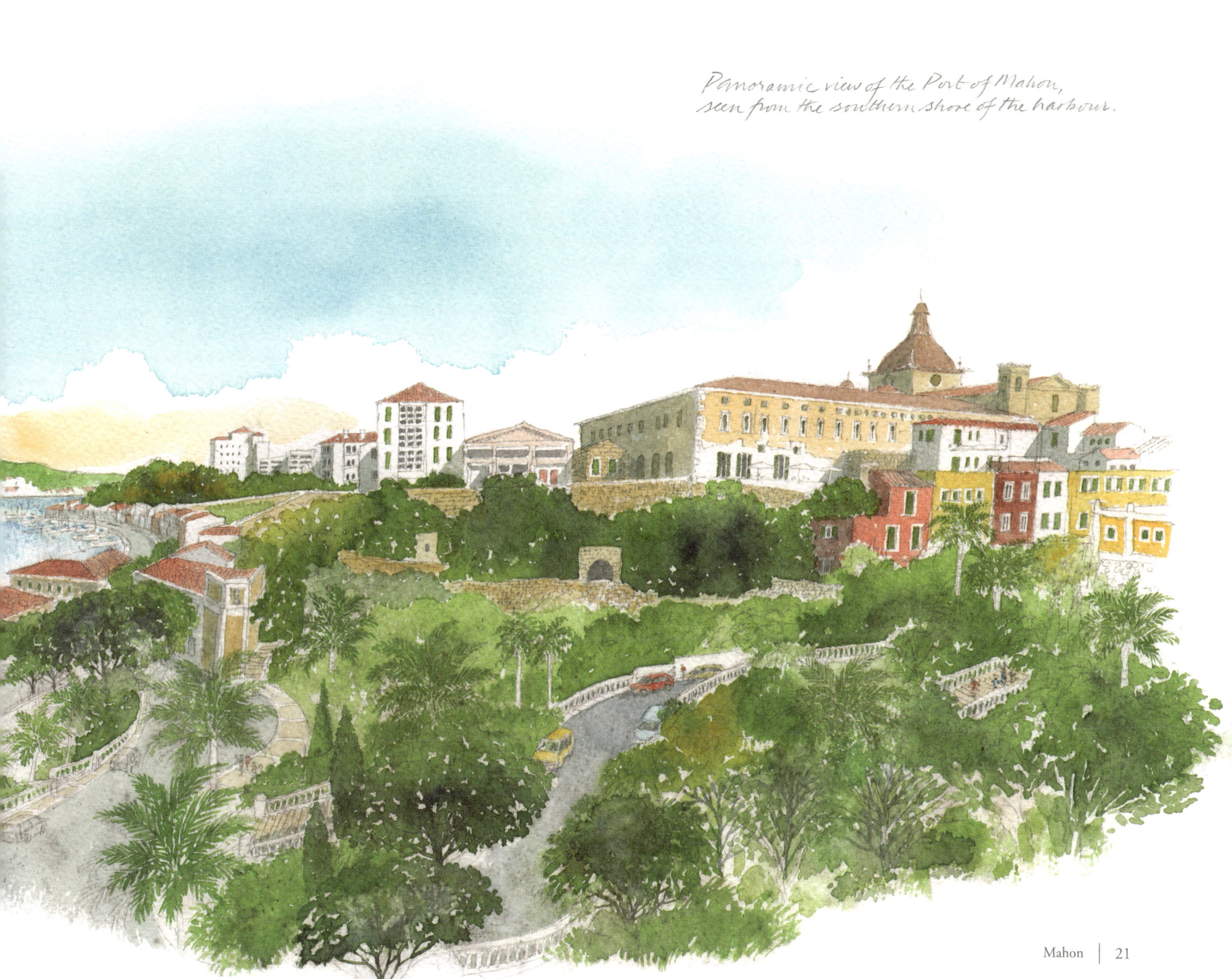

Panoramic view of the Port of Mahon, seen from the southern shore of the harbour.

Mahon

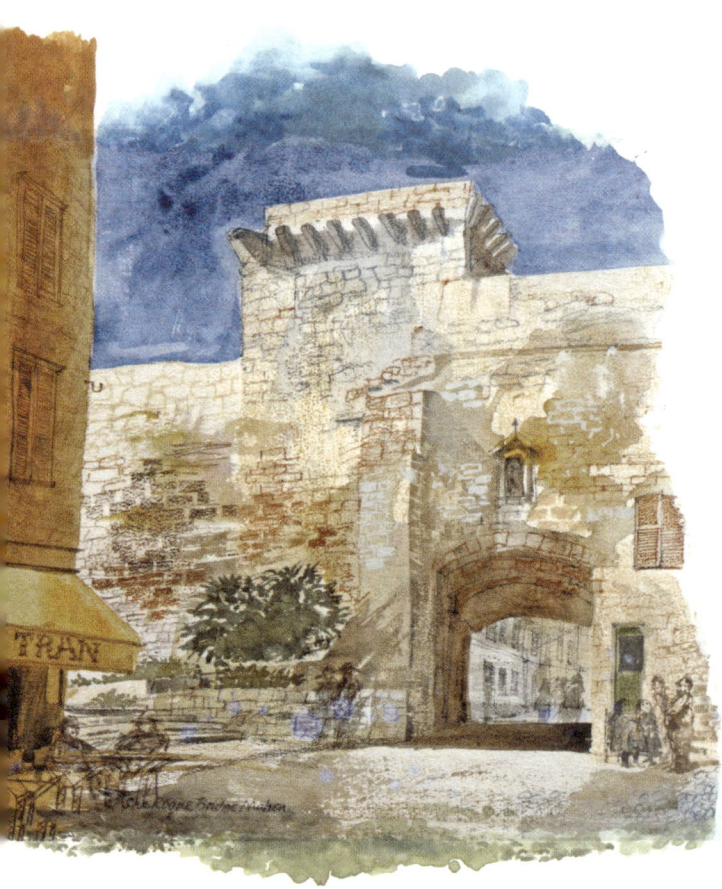

Ca n'Oliver, a former grand merchant's house, now beautifully restored and showcasing a wonderful art collection and historic maps detailing the history of the family and the British legacy in Menorca.

Sant Roque Arch, all that remains of the ancient city walls of Mahon.

Plaza de Colon, also known as Plaza de las Palmeras, for its characteristic palm trees.

22 | Menorca Sketchbook

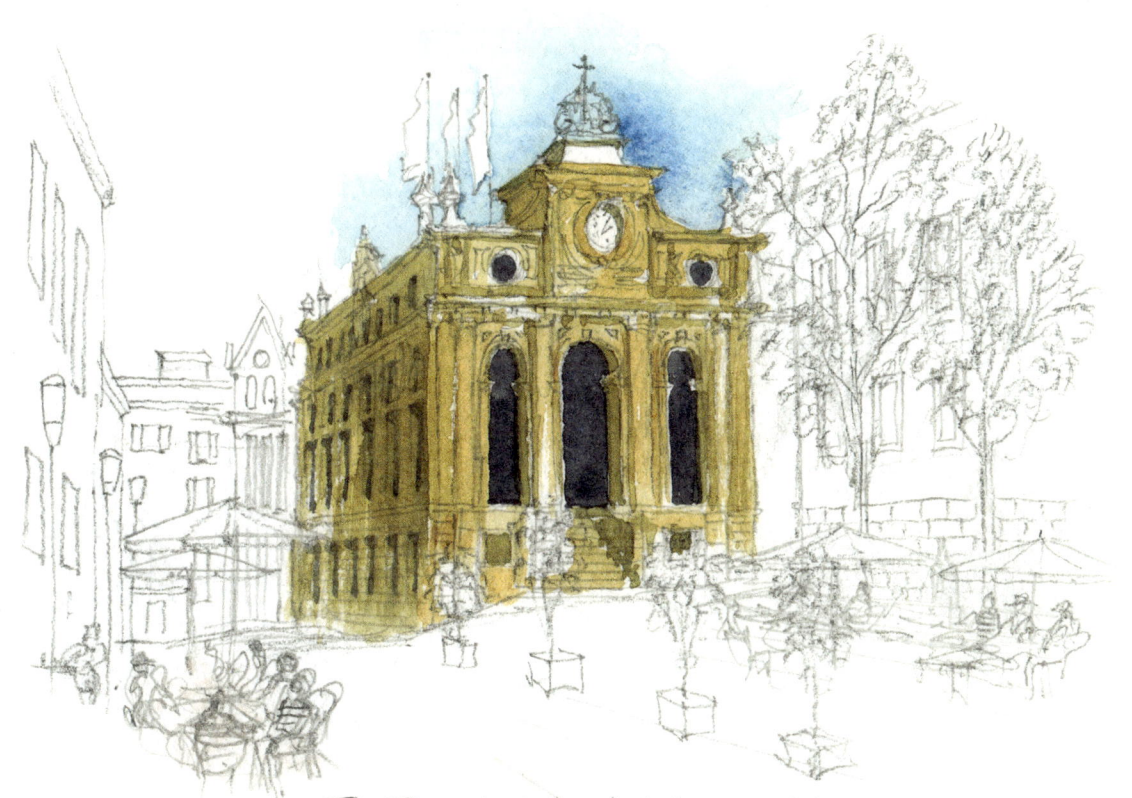

The Town Hall (1613), later embellished by a fine English clock in the 18th century.

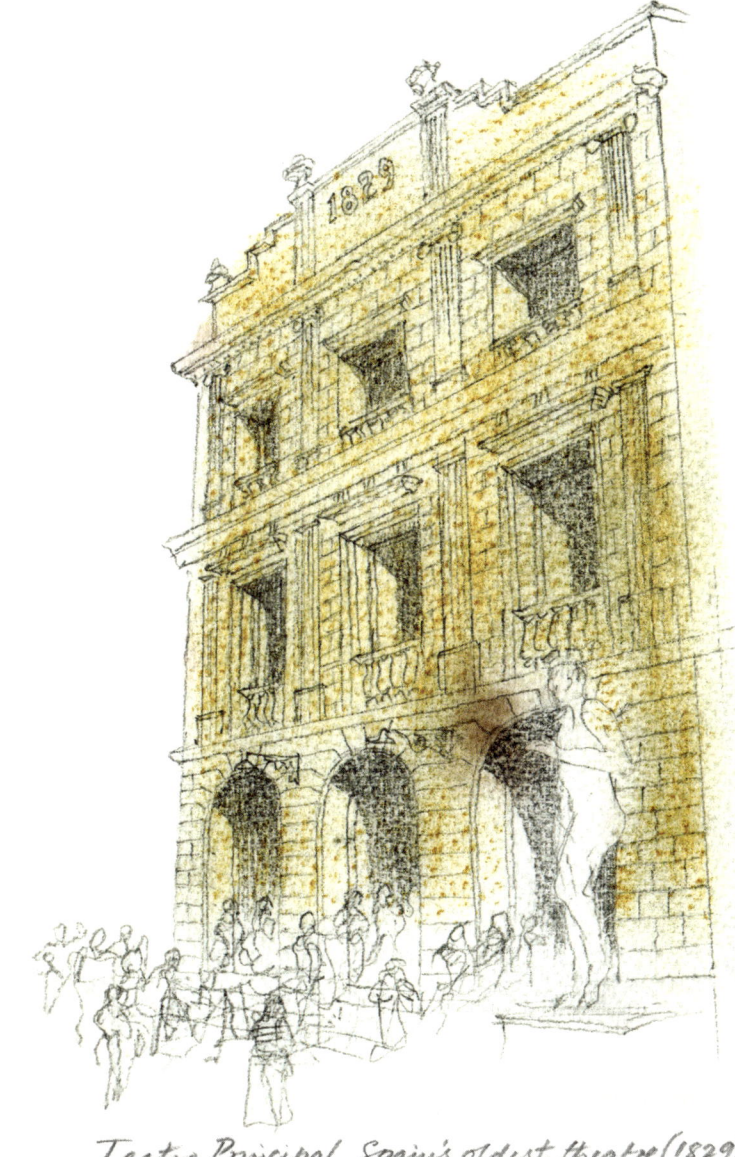

Teatro Principal, Spain's oldest theatre (1829), built in the classic Italian style. It offers a vibrant programme throughout the year, including a world-class operatic series.

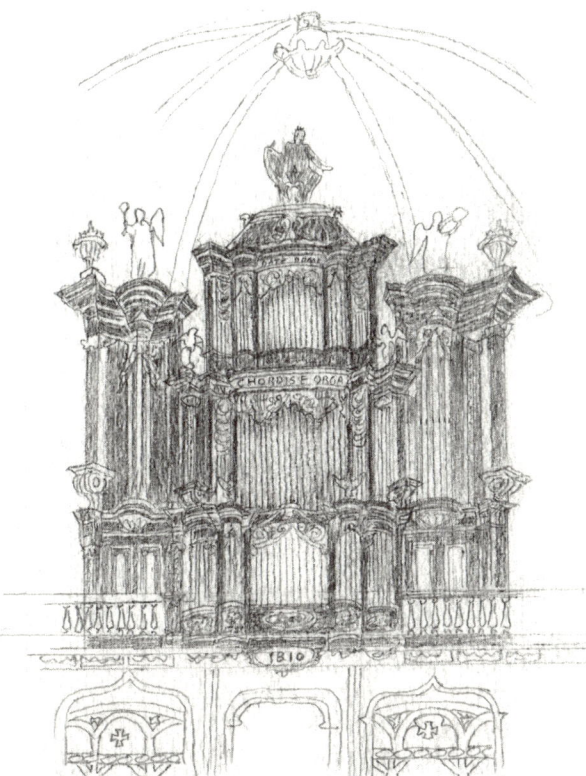

The organ, installed in the church of Santa Maria in 1810. In the summer there are regular concerts.

Mahon | 23

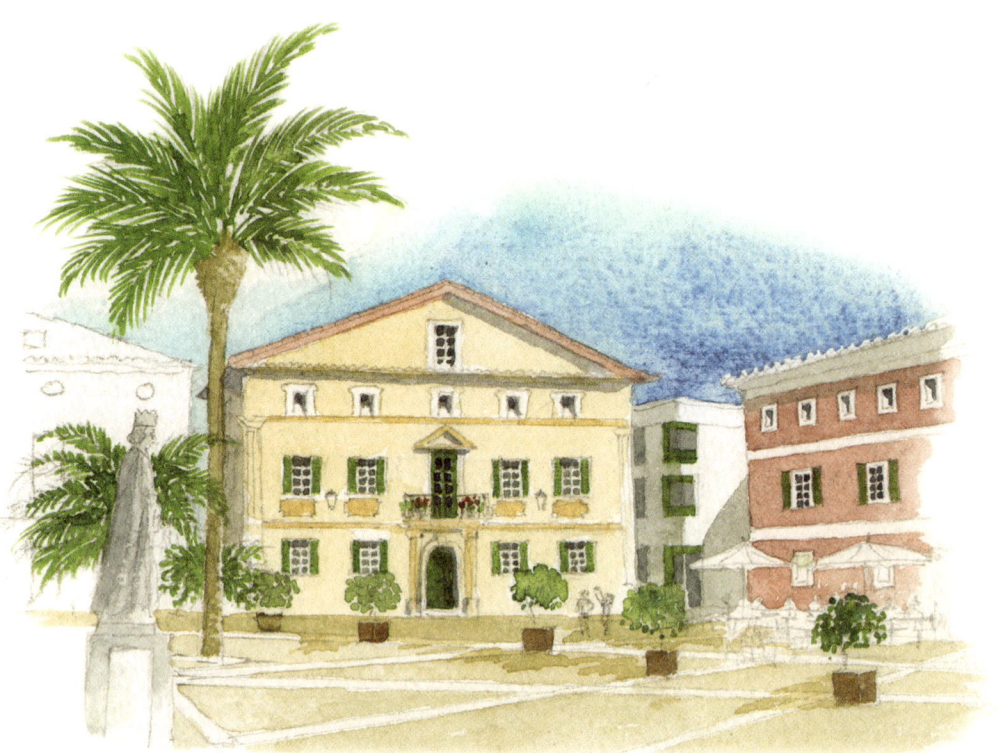

Plaza Conquista, home of the city's library, and a statue of Alfonso III of Aragon, who conquered Menorca in 1287 in the name of Christianity.

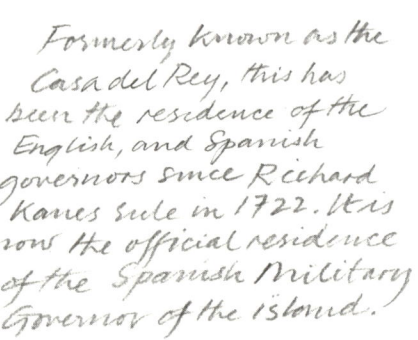

Formerly known as the Casa del Rey, this has been the residence of the English and Spanish governors since Richard Kane's rule in 1722. It is now the official residence of the Spanish Military Governor of the island.

Menorca Sketchbook

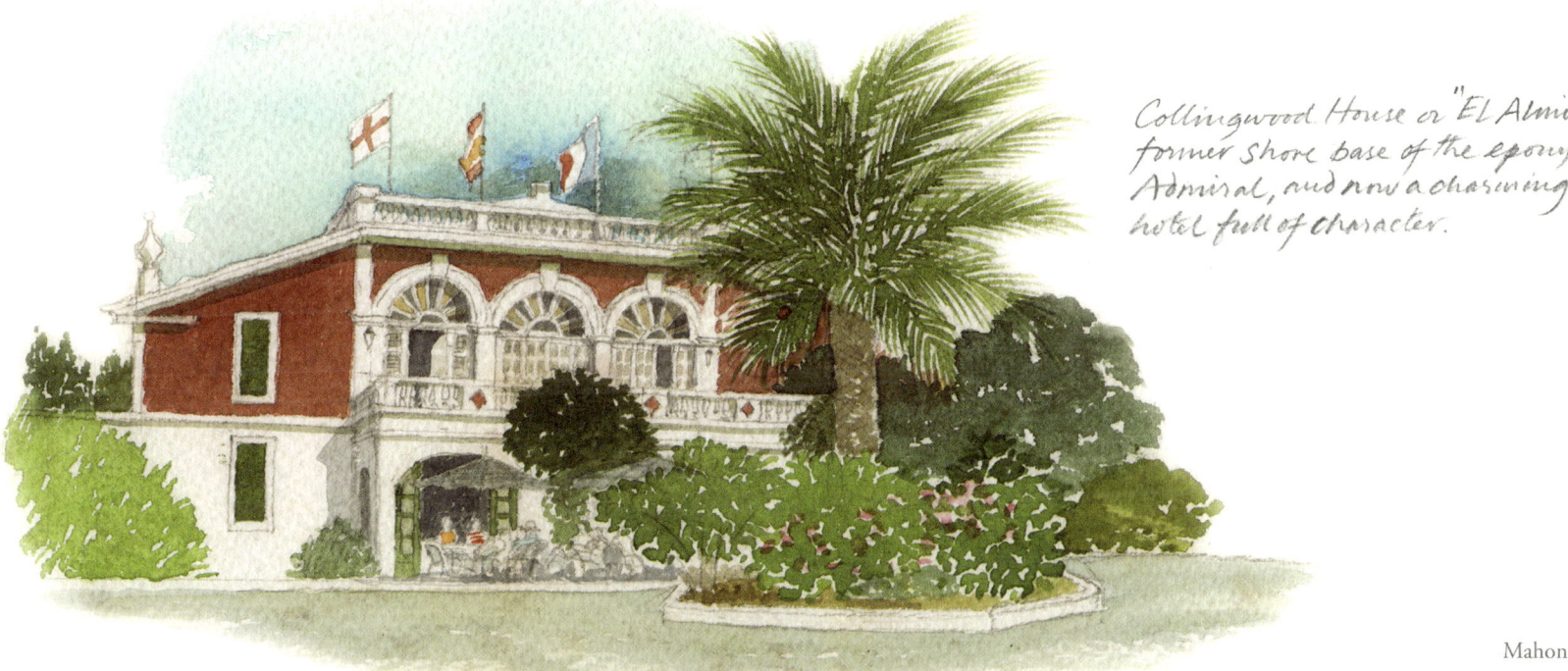

The Fish Market. Another masterpiece by architect Francesc Femenías, has operated since 1927. It now offers an exciting range of tapas, wines and speciality beers, alongside the best fresh fish and shellfish.

Collingwood House or "El Almirante", former shore base of the eponymous Admiral, and now a charming small hotel full of character.

Mahon | 25

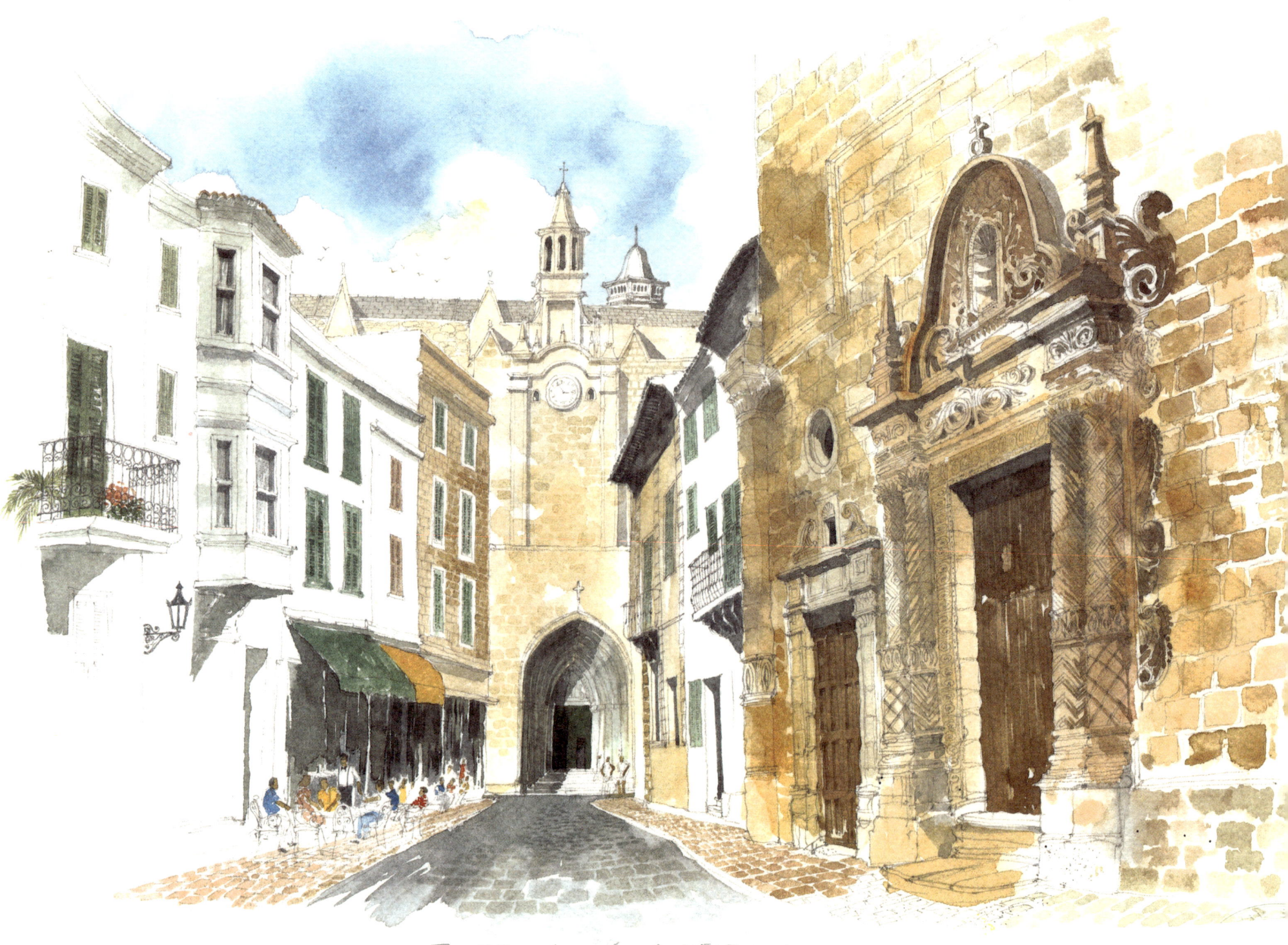

The 18th century church of El Roser is now an art gallery and leads to the Cathedral square. Note the beautifully-carved portals on the facade.

Ciudadela

Ciudadela is a wonderfully-preserved historic city virtually without a blemish, alive and lived in as Spain's ancient cities always are. Much of its beauty comes from the glowing honey-coloured "marés" stone of its churches and palaces. No less a delight are the streets of lesser houses, painted in pretty, varied colours without a discordant note. Almost best of all is the complete lack of traffic in the old town.

The grandest sights in the city are the two massive 17th century spear bastions overlooking the port.

A broad stairway ascends from the harbour to the Plaza del Born, a foretaste of the civic splendours of the ancient capital of the island. In the centre of the square is a 22-metre high obelisk, commemorating the Turkish assault in 1558 and the fierce resistance of the local inhabitants. The 1875 theatre has a handsome Palladian front. To the west is the elegant 19th century Town Hall constructed over the ancient Arab citadel, in neo-Romanesque style, with deep-set arcade and stout columns with richly carved cushion capitals. Be sure to ascend to the first-floor council chamber, with imposing stone arches supporting a timber roof inset with armorial panels.

Across the square stand two fine baroque palaces, crowned with open-arched loggias, that of the Counts of Torre Saura on the left and the narrow Salort palace on the right. Between them opens the street which leads to the Cathedral square and continues past shops set in shaded medieval arcades towards what was the eastern city gate.

The imposing cathedral, begun at the time of the Christian reconquest in 1287 and completed in 1362, appears as much fortress as church, which explains why it is one of the few Gothic buildings to survive the sacking of the city by the Turks. The bell tower was once the minaret of the mosque which stood here before the church. The lesser churches are beauties too - the 1667 baroque Chapel of Sant Crist and the late 17th century Church del Roser, with three gorgeously carved portals.

Seek out the thriving market area as well. The meat stalls are ranged on one side, faced with pretty green and while tiling. In front is the 1869 fish market in a neat free-standing pavilion with a raised roof providing ventilation. The whole area is surrounded by graceful arcades with bars and shops.

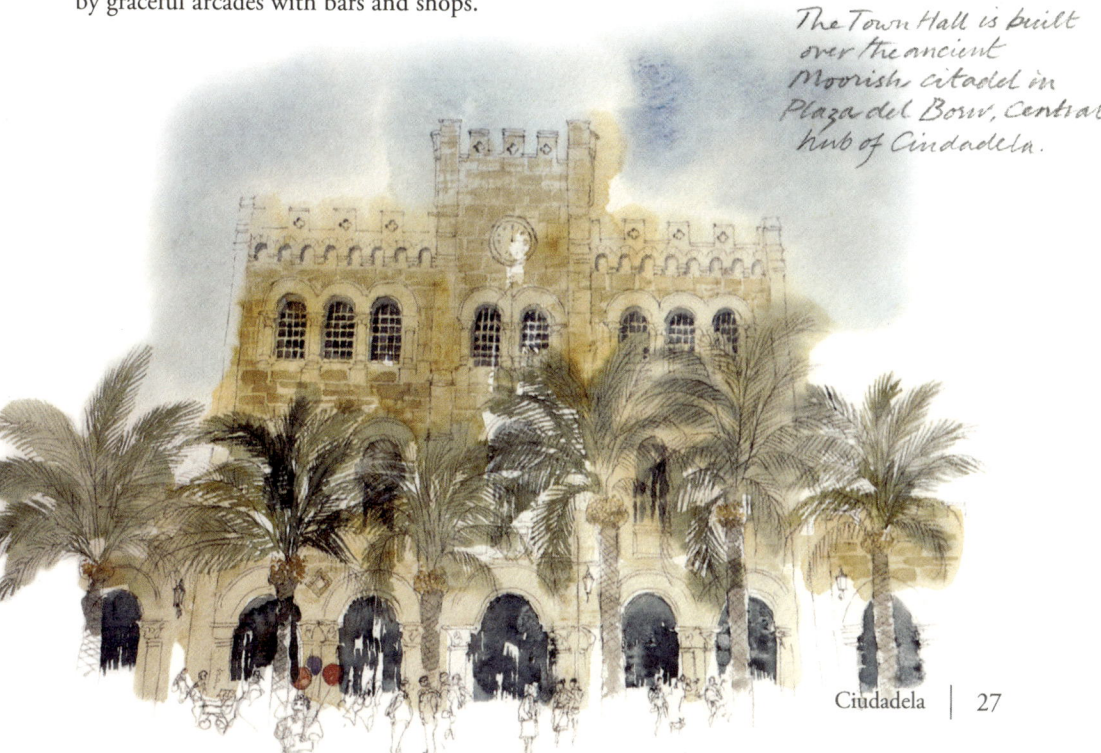

The Town Hall is built over the ancient Moorish citadel in Plaza del Born, central hub of Ciudadela.

Dominating the Plaza del Born, the obelisk was erected in the 19th century in memory of the devastating Turkish invasion of 1558, when, despite fierce resistence from the local population, 3,452 citizens were abducted and sold into slavery in Constantinople (present day Istanbul).

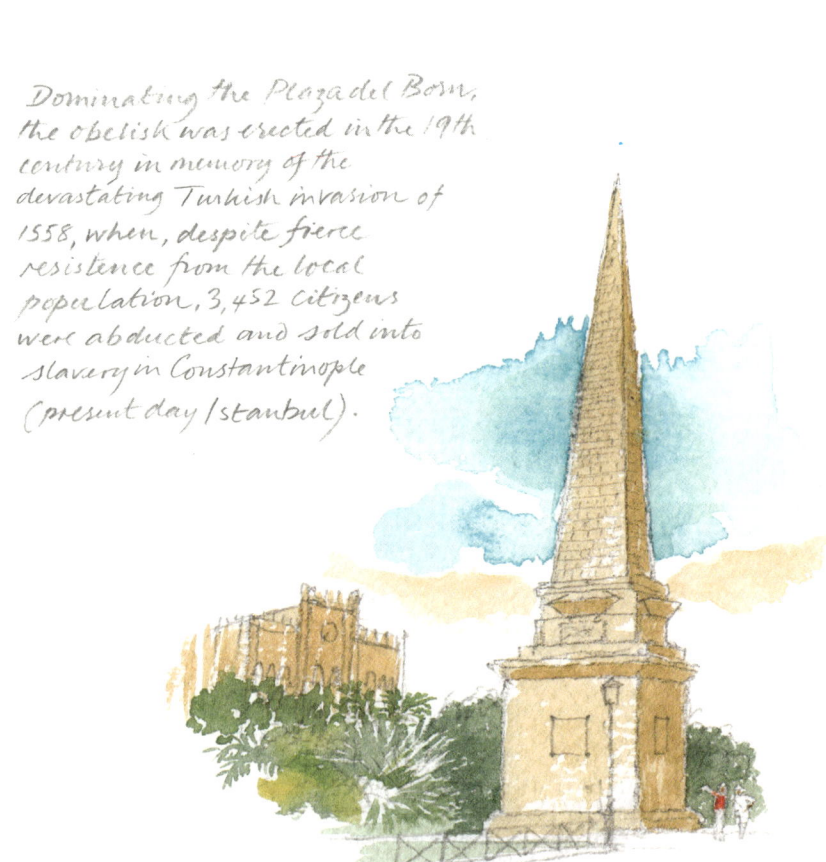

The Theatre in the Plaza del Born was built in 1875 by Roman Cavalier Gelabert. It has been undergoing restoration for several years.

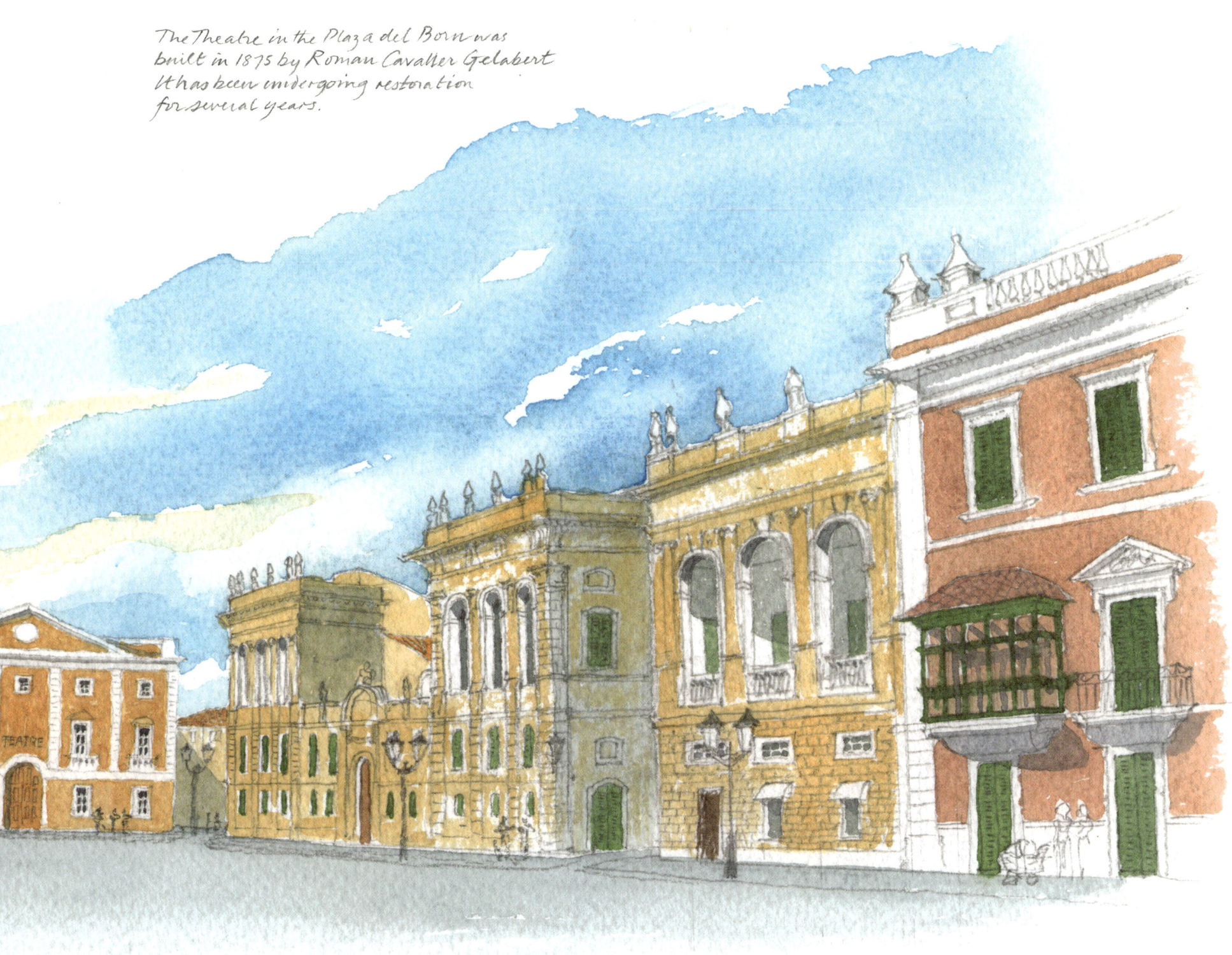

Ciudadela | 29

Known as "boinders" (a corruption of "bow windows") these iconic covered balconies adorn many of the city buildings, also in Mahon, and date back to the British presence in the 18th century, together with the Georgian-style sash windows.

Classic buildings in Plaza del Alfonso III, named in memory of the 1287 Christian conquest of Menorca.

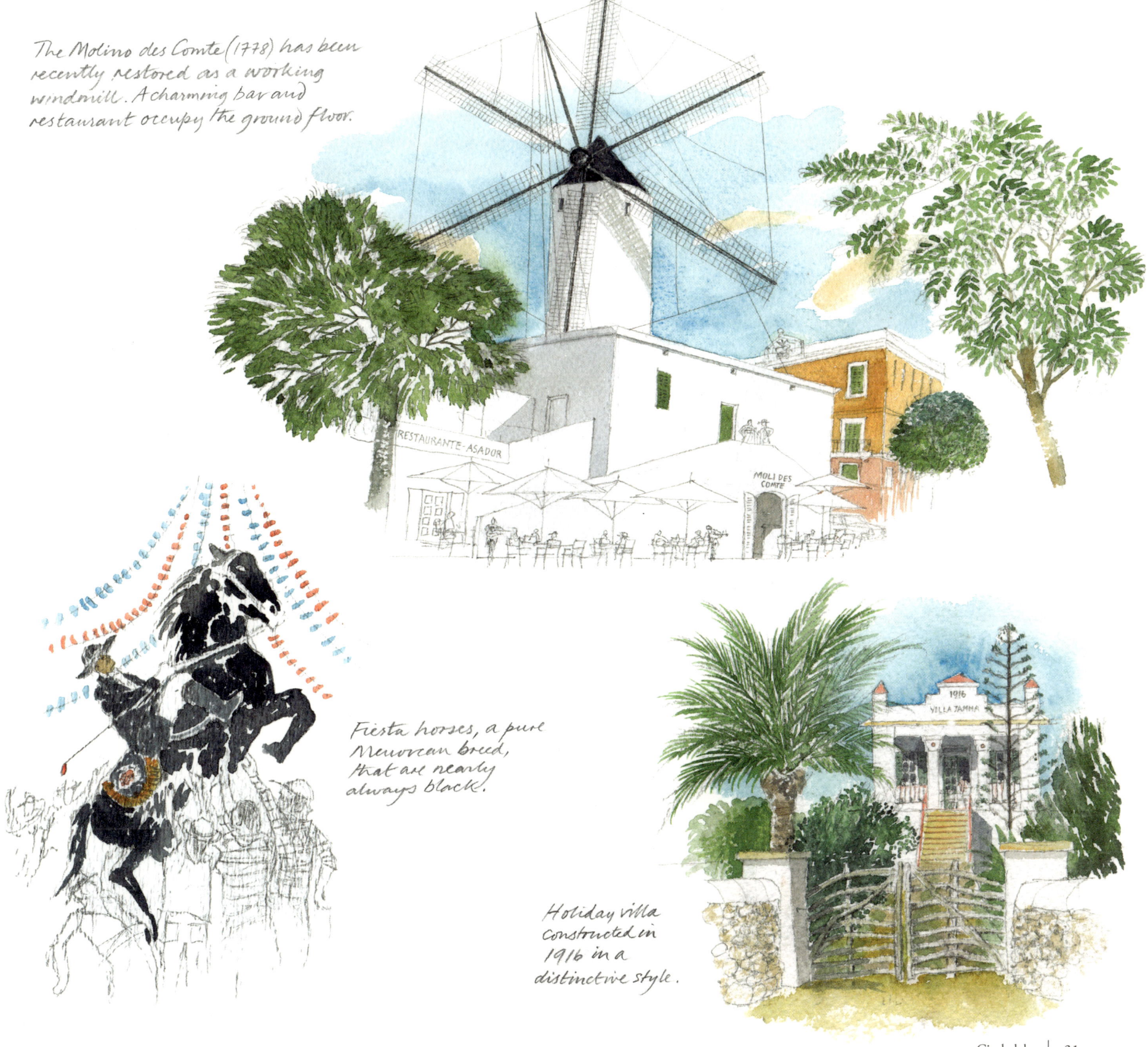

The Molino des Comte (1778) has been recently restored as a working windmill. A charming bar and restaurant occupy the ground floor.

Fiesta horses, a pure Menorcan breed, that are nearly always black.

Holiday villa constructed in 1916 in a distinctive style.

Ciudadela | 31

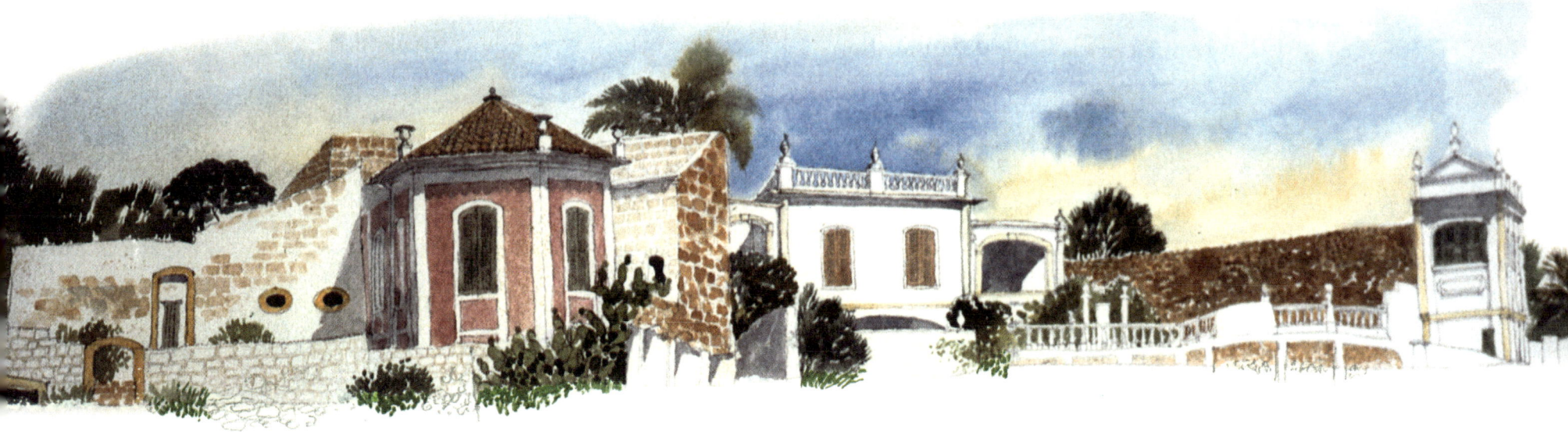

A lot of the old buildings are used for entertaining and the area has a thriving night life.

Paseo de San Juan. Scene of the Fiestas of San Juan in June which attract thousands of visitors. They are the first of the fiestas which take place in every town during the summer.

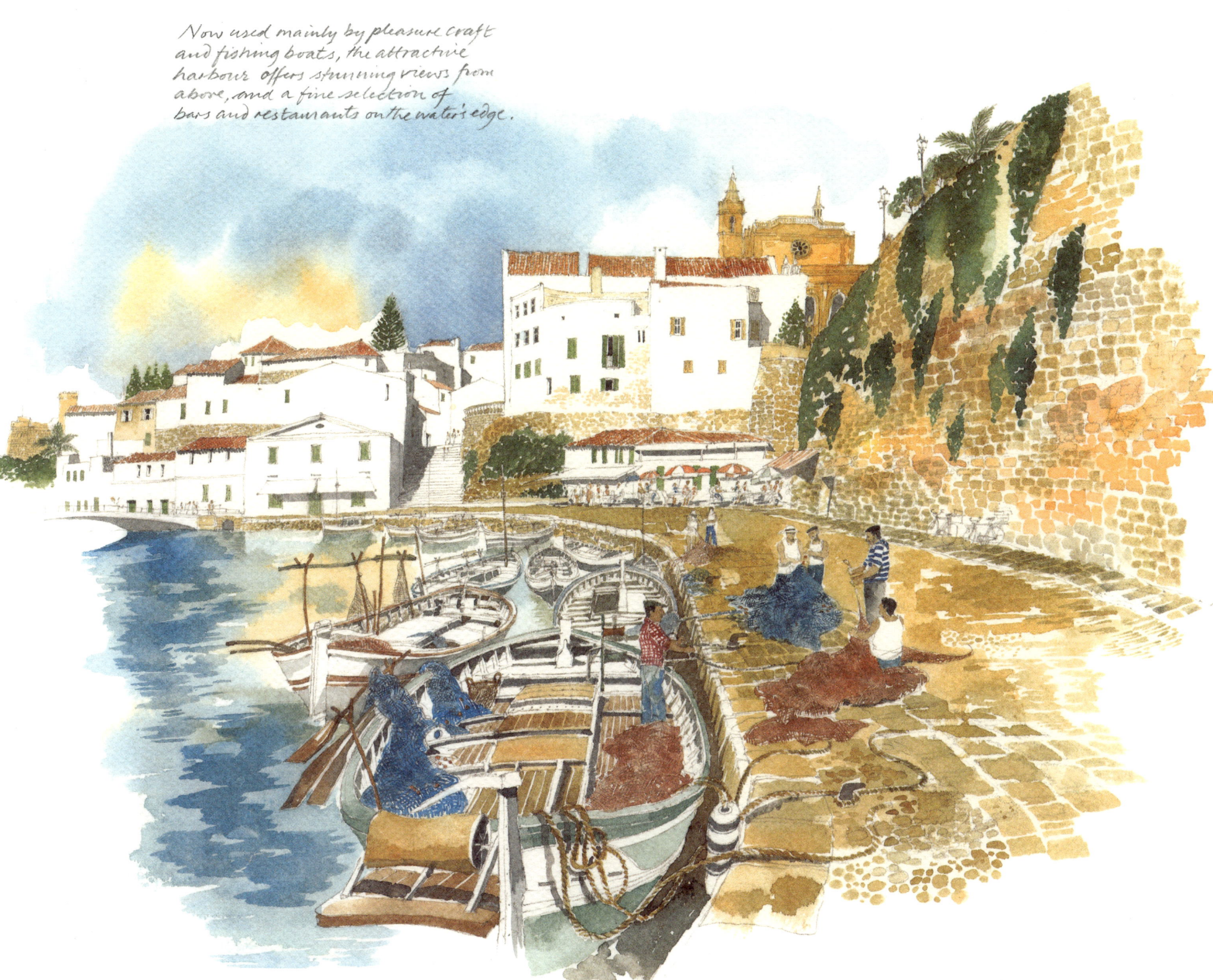

Now used mainly by pleasure craft and fishing boats, the attractive harbour offers stunning views from above, and a fine selection of bars and restaurants on the water's edge.

Ciudadela | 33

The patio of the Diocesan Seminary.

No 5 Calle de Seminario, in the centre of the town.

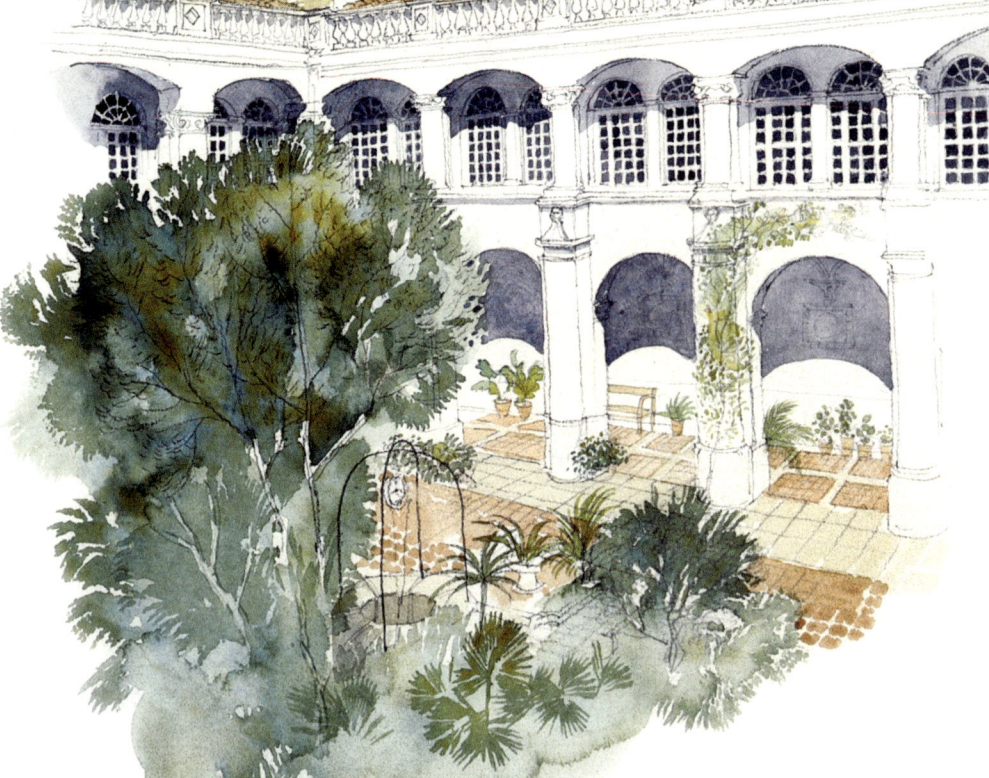

The majestic Cathedral of Santa Maria, constructed in the Catalan-Gothic style and built on the site of a Mosque. The remains of the old minaret can be seen inside the building.

34 | Menorca Sketchbook

The market is where locals and visitors throng for fresh fish, meat, fruit and vegetables and meet with friends and family in nearby bars.

The narrow streets and moorish style arches of Ses Voltes date back to pre-Christian era. Now home to shops and restaurants

Ciudadela | 35

Villages

Every town in Menorca, large or small, has its own annual and very popular fiesta, beginning with Ciudadela in June and reaching a new climax in September in Mahon. The centrepiece always is a display of Menorca's magnificent stallions. Streets are covered in sand to protect their hooves as 'young bloods' encourage the horses to rear up on their hind legs and prance for several yards while riders take off their hats and ride with one hand on the reins to show off their horsemanship – both long-haired teenage girls and sturdy country squires. Many local dignitaries also participate in these spectacles. It is beholden on any newly-elected mayor to acquire riding skills!

The three main inland towns, Alayor, Es Mercadal and Ferrerias, are all worth an hour or more's exploration through winding streets to admire their venerable churches. In Alayor, note the decorative window surrounds which are a trademark of a local master builder named Gomila. The houses and gardens backing onto to the rainwater channel in Mercadal are especially picturesque. Ferrerias, en route to Ciudadela, just off the bypass, is traditionally home to several of the famous shoe makers, and stands in beautiful natural surroundings.

The three planned towns of San Luis, Es Castell and San Clemente, all on grid plans, are also worth a diversion into side streets to look at houses, gardens and taverns. Es Castell has many British residents and a well-attended and pretty Anglican Church, Santa Margarita. Steps descend to Calas Fonts, a cove lined with attractive bars and restaurants, some of them occupying fishermen's caves, and overlooking a small harbour packed with fishing boats.

The charming village of Es Migjorn Gran has become a favourite with artists and musicians. Llucmaçanes is a quiet and secluded hamlet dominated by a tall church, while Torret is worth a stroll to admire the whitewashed farmhouses, including a fortified 12th century tower set end on to the road in an enchanting and well-preserved small village.

The inland towns have been busy restoring their windmills and other landmarks, such as the barracks in Mercadal converted into a craft centre. There are also some classy new buildings – a vineyard and restaurant just outside San Luis, a new theatre in Mercadal and a modern public hospital.

Menorcans, like all Spaniards, enjoy city life and it spills out into the streets of towns and villages with cafes, bars and family-run shops, offering a warm welcome to visitors and residents alike.

Alayor, founded in 1304 on the site of an old Moorish farmstead. The Church of Santa Eulalia dominates the landscape. This area is the original birthplace of Menorcan cheese which is now internationally respected.

Alayor

San Diego. A quiet discussion outside the church.

A former school, now a print centre with contemporary etchings and lithographs.

Villages | 37

Es Castell

Es Castell Town Hall today, painted in the typical historic red colour much favoured by the British in the 18th Century.

The Military Museum. A former British military barracks has a fascinating collection of memorabilia. Well worth a visit.

A windmill recently restored by local volunteers in Es Castell. In the 18th century they were used for grinding wheat to feed the large military presence on the island.

Menorca Sketchbook

Bar Lemon. Famous for its International cocktails.

Bar España. An iconic hostelry dating from 1948. Still very popular.

The old military parade ground in Es Castell before recent restoration. It is now the town's main square, known as the Esplanada.

Calas Fonts. A colourful fishing port where you can witness the first sunrise, as it is the most easterly town in Spain.

Villages | 39

Fornells

Charming fishing port and home to the "Caldereta," the traditional lobster stew served in the local restaurants around its palm-lined harbour. Popular centre for dinghy sailing, windsurfing and scuba diving.

The sympathetically-restored port office which occasionally has small music events.

One of the largest and best-preserved defence towers in Menorca, built by the British between 1798-1802 to guard the entrance to the bay.

Menorca Sketchbook

Ferrerias

Menorca's highest town, home to shoe manufacturing and other light industries. Every Saturday there is a lively local produce market.

Menorcan crafts.... winemaking, cheese and the famous Menorcan sandals known as abarcas.

Hort de Sant Patrici has produced its own wine since 2000. One of several vineyards now making Menorcan wine. Just 2km north of Ferreries the main building houses a small hotel and restaurant.

Es Mercadal

It is the geographic centre of Menorca at the foot of Monte Toro, the island's highest point. It is a pretty whitewashed village with quaint streets, interesting shops and fine restaurants.

The church of St Martin dominates the village, with its simple, solid-block bell tower.

Es Moli d'es Raco, emblematic windmill, whose rustic restaurant offers traditional hearty Menorquin cuisine year round.

Es Mercadal from across the fields

The craft of the traditional olive wood Menorcan gate has existed in the village for centuries.

Villages | 43

Es Migjorn Gran

Dating back to 1768 when the church of San Cristobal was built, Es Migjorn is still a sleepy hamlet, but with many hidden secrets, including some very fine restaurants and bars. In alternate years the village hosts a Music Festival and the Migjornale Art Festival, when many village houses open their doors to exhibit art.

Can Piris built in 1887 is a fine country house as you enter the village.

Ca Na Pilar offers fine dining.

44 | Menorca Sketchbook

A country farm.

ESGLÉSIA PARROQUIAL DE SANT CRISTÒFOL

Church of San Cristobal

Bar Peri. Everyone's favourite bar.

Behind this door is a traditional Menorcan restaurant.

Bar Chic. Food and views to die for.

Villages | 45

San Clemente

Beautifully preserved talayot of Torelló. It has an unusual aperture complete with lintel towards the top.

Church of San Clemente commenced in 1819.

Casa Gonyalons dated 1891 by Juan Rubia i Bellver but looks more like "Art Deco" 1920.

Menorca Sketchbook

San Luis

Moli de Dalt built in 1762 is now an ethnographic museum.

The town was built by the French as their capital, after they invaded Menorca in 1756. They began with a church dedicated to King Louis. However in 1763 the Treaty of Paris ceded Menorca back to Britain.

The Aero Club. 50 years old in 2019

Villages | 47

Countryside

Menorca's countryside may seem tame compared to the mountain scenery of Mallorca and, while parts are flat, much of the island consists of gently rolling hills with a farm every half mile. The soil can be as richly red as Devonshire in England, but much of it is almost biblically stony – hence the ubiquitous dry-stone walls – which are generally very well maintained, inset with stone sheep shelters barely larger than dog kennels and even with stone rings encircling individual trees.

The traditional field pattern is little changed and intensive agri-farming is rarely in evidence. Both trees and scrub alternate with fields which rise up and down the hills despite the challenges this presents to the ploughman.

Everywhere the farmhouses stand out, with red tiled roofs and white walls. The farmhouses are all on a pattern – simple geometric volumes perfectly scaled to the landscape. At most of the working farms there are numerous outbuildings, old and new, clustered round the farmhouse with cattle byres and barns for storing hay.

Menorcan gates, found all over the island, are made of bent olive branches, intended to last as long as the trees themselves. The best way to enjoy the deep peace of the Menorcan countryside is to take the Kane's Road, which runs past farms and manor houses untouched by the modern world.

The southern ravines are a natural wonder, sixteen of them noteworthy, shaped by water over millennia and protected from strong winds. Here are roosting spots for the Egyptian vulture and caves which were once the habitats of humans as well as bats. The largest is the Barranc d'Algendar, which runs from Ferrerias to Cala Galdana, seven kilometres long and often rising between sheer cliffs.

Menorca also has several precious well-preserved wetlands, with both fresh water and salt water, notably the Albufera d'es Grau adjacent to Es Grau, extending to 5,000 hectares. Spring and autumn are the best time to watch migrating birds.

Monte Toro, with its monastery, is almost in the exact centre of the island and stands 1,000 feet above sea level. From the top there is an uninterrupted 360° view of the entire island. The east end of Menorca is the first place in Spain to see the sunrise while the west coast is perfect for sunsets, looking across to the mountains of Mallorca on a clear day.

A recent phenomenon is the recent introduction of characterful rural hotels set mainly in old farm houses with thoughtfully restored interiors and gardens, often with a minimalist touch and excellent cuisine.

Wild flowers are a spectacular sight in springtime throughout the island.

Cattle abound in Menorca and are important to the milk and the cheese industries.

Countryside | 49

Traditional threshing circle still used today on certain farms to separate the wheat from the chaff.

The gates and walls keep the animals secure. But you can do nothing to protect the trees from the wind.

Hoopoe, Menorca's favourite bird.

50 | Menorca Sketchbook

Menorca has numerous
natural wells which come
in many different shapes
and sizes.

Countryside | 51

The farm on Cami d'Kane,
S'Aranjassa.

The country houses in past
centuries often had defence
towers built onto them to be
able to look out to sea in
case of pirates and to be a
refuge to local inhabitants.
Torre de S'Atalaya is a
fine example.

52 | Menorca Sketchbook

Montsessat on the Cami d'en Kane is a fine 18th century house painted in red as many were during the British occupation

The oldest bridge on the island was built under the order of Governor Kane to help movement of troops along the Cami d'en Kane.

The old Lithica stone quarry, now a visitor attraction, also offers summer concerts in a remarkable setting.

Countryside | 53

Camí d'en Kane transects the island through wonderful landscape with very little traffic to disturb its tranquility.

Barns appear in various styles, built to accommodate the storage needs of specific farms.

Private churches were often added to grand houses in the 18th century. This one has a Gaudiesque style.

54 | Menorca Sketchbook

This shows the farmer using different ways of ploughing.

The roman plough is still used today. The farmer can stand on it to help the plough to go deeper. Or he can stand behind it and plough holding the long handle at the back.

Countryside | 55

Binissues, now a popular restaurant in a fine and imposing building, which also houses important farming, ethnographic and natural history museums.

This 18th century manor house, formerly a Moorish fortress, is now a delightful Hotel Rural, Alcaufar Vell.

Binissafuller is a large country house built in the 19th Century. It has an unusual swept-up gable.

The Subaida estate dates from the mid-19th century and has been in the same family for six generations. Cheese making began in 1930 and has won international awards.

Monte Toro, at 342 metres, the highest point, topped by the Sanctuary of Verge de Toro. The chapel is popular for weddings and the 360 degree view of the whole island is spectacular. A place of pilgrimage since the 13th Century.

In recent years there has been a trend to develop characterful "Rural Hotels" out of historic and often previously abandoned properties. Santa Ponsa, Biniarroca, Bini Gaus Vell and Experimental are notable examples amongst many others on the island.

58 | Menorca Sketchbook

The prehistoric village of Trepucó, 5th century BC when it was the centre of power in eastern Menorca, offers excellent examples of both the Talayot and the Taula.

When walking the countryside you find such a variety of artefacts from old carts, prehistoric sites and an amazing collection of signs to help you on your way.

Countryside | 59

Fornells has existed for centuries as a fishing village. The "Lobster Caldereta" is a speciality. There is a well-restored 18th century defence tower and ruins of the fortress of San Antonio. In the harbour there are unique Menorcan fishing boats known as "Llauts."

The Coast

Menorca's coastline is wonderfully varied with sandy beaches alternating with hidden coves and stretches of imposing cliffs. The north coast is relatively bare in places, partly thanks to the Tramontana, a fierce north wind like the famous Mistral in southern France, which stunts the growth of trees and used to lead farmers and villagers to retreat into an inner windowless room while it lasted. For this reason, many farmhouses have no north-facing windows.

Elsewhere coves and beaches are ringed by lush pinewoods, which remain a fresh and brilliant green year around, often with a delightful fisherman's hut set enchantingly at the water's edge.

Many beaches and coves have excellent information panels with maps and aerial views as well as suggestions for coastline walks which link up to form the Cami de Cavalls, an ancient coastal track that encircles the island and has recently been restored for walkers and riders. It is approximately 186 km long.

Menorca was defended by a series of Martello-style towers, mostly built during the third British occupation 1798 to 1802, and matched by seven handsome lighthouses. Mahon harbour, one of the best natural harbours in the world, is worth exploring both by water and by road. The white-walled Anglo-American cemetery on the water's edge is a memorably peaceful place recalling that the US Mediterranean Squadron were based in Mahon from 1815 to 1843.

Alcaufar is a lovely long creek where Menorca's first tourist hotel was built in 1947, with a pine-shaded terrace restaurant looking out over sparkling blue water. The Caves of Xuroy set in high cliffs on the south coast offer fine views, especially at sunset, with music and dancing until late in the evening.

Calas Coves on the south coast is home to more than one hundred burial caves dating from 1200 BC.

Binibeca Vell, with its white painted walls and roofs is a romantic recreation of a traditional Mediterranean fishing village, while Son Bou is a long beach of ravishing white sand and turquoise sea.

One of the loveliest sights on the north coast is the bay of Fornells, an area as large as Mahon Harbour though much shallower. The whitewashed village stands behind a line of palms and the promenade is so low that you can sit dangling your feet in the water. Es Grau is a pretty hamlet set on a spit in another attractive bay. Restaurant and bar terraces stand directly on the water and nearby are two enchanting little "fin de siècle" seaside villas. The Isla de Colom, the largest offshore island, is close by and always a popular destination for the many local boat owners.

Two-thirds of the Menorcan coastline is also a protected zone for birds, fish and other wildlife, with strict shoreline rules in force to prevent damage and exploitation.

The designation of Menorca as a Unesco Biosphere Reserve has introduced welcome new safeguards for both the sea and the landscape and limits the construction of high-rise developments which became so controversial in the 1960s in the Balearics.

Pregonda is one of the most exquisite beaches on the North coast. Right on the beach itself there is a unique white house which has an influence of Gaudi's architecture.

The Coast | 63

Binibecca Vell, winner of architectural awards for recreating a traditional fishing village.

Local fishermen still utilise time-honoured methods in pursuit of their trade.

Mesquida. A quiet fishing village not far from Mahon. But in 'another world.'

The Coast | 65

Port of Addaya on the north coast, is a favourite marina for yacht owners.

Sir Robert Baden Powell, a regular visitor to Mahon. She is a 42 metre staysail schooner built in 1957.

Hotel Xuroy, Alcaufar. First 'resort hotel' in Menorca opened in 1947 and still going strong.

The Coast | 67

The original beach houses on Punta Prima beach.

Two popular bars on the south coast are proud to boast brightly coloured doors on ancient fisherman's huts.

S'Albufera d'es Grau. Protected wetland and haven for migrating birds.

68 | Menorca Sketchbook

Traditional llaüts, unique to Menorca, and still much in use today for both fishing and recreational boating.

Catch of the day!

One of the oldest fisherman's cottages in Es Grau.

The Coast | 69

The lighthouse at Favaritz on the north coast.

Defence towers were built all around the coast, by both the Spanish and the British in centuries gone by. Here are two of the finest, both protecting the approaches to Ciudadela. Torre de Castella, Santandria and Saint Nicholas.

70 | Menorca Sketchbook

The prehistoric settlement of Sa Torreta has a Taula and defence tower looking towards the Isla de Colom.

The Cami de Cavalls (approx 185 kms) was originally developed in the 18th century to allow the coastline of Menorca to be patrolled and protected on horseback. Now it has been reopened it gives great pleasure to riders, walkers and cyclists.

The Coast | 71

Artist's Acknowledgments

I first came to settle in Menorca way back in 1995, having previously enjoyed many happy family holidays on the island. I was immediately attracted by the intensity of the light and the delightful and very varied styles of architecture all over the island, coupled with the peace and tranquility, and the charm and generosity of the local people.

This is the tenth book in my worldwide Sketchbook series, but the first one dedicated solely to our beautiful island. There are so many unique features, that the challenge has been what to leave out rather than include. Inevitably I have missed some real gems, but I have tried to encompass some of the curiosities as well as well-known highlights and to give a flavour of what makes Menorca so special to us all.

My acknowledgements are many, and include a number of my loyal patrons (they know who they are!) whose properties I have been privileged to paint over the years. Marcus Binney, my writer, another longterm visitor to the island, contributed his unique take on the varied and sometimes quirky architectural delights, and I have received huge support and encouragement from my many friends and of course my family.

I especially commend my editor, Lorraine Ure, whose knowledge of the island's history and culture, has been very important to the essence of the book. Also my patient translators (for the Spanish edition), Chele Fox, Irene Cardona, and also Ros Thomas (for the captions). Again my Singapore production team have been exceptional in their professionalism and dedication.

I do hope we have done justice to their beautiful island.

The Menorcan Cricket Club. Established in 1985.